POST-IMPRESSIONISM

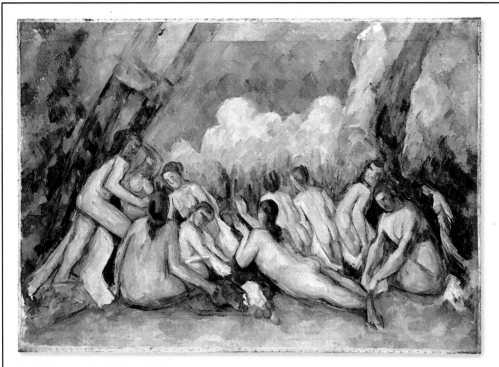

Paul Cézanne, *The Bathers*, c.1895

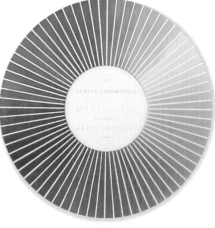

Chevreul's "color circle"

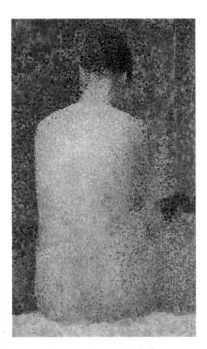

Georges Seurat, *Study for Les Poseuses*, c.1887–88

Letter from Paul Cézanne to his son

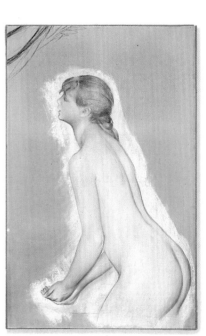

19th-century camera

Silver brooch by Paco Durio, 1904

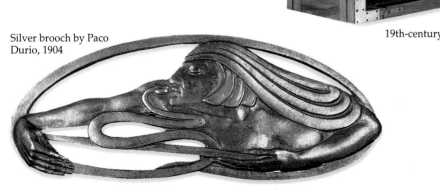

Pierre-Auguste Renoir, *Study for The Bathers*, 1887

EYEWITNESS 👁 ART

POST-IMPRESSIONISM

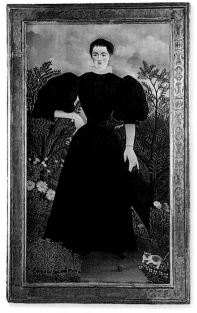

Henri Rousseau,
Portrait of a Woman, 1895–97

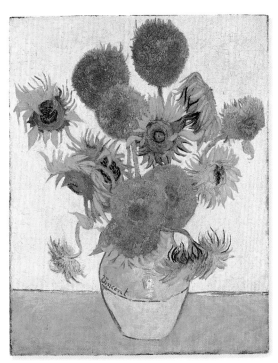

Vincent van Gogh, *Sunflowers*, 1888

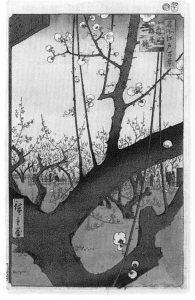

Audo Hiroshige,
Flowering Plum Tree, 1857

Edgar Degas, *Woman
Drying her Left Hip*,
c.1896–1911

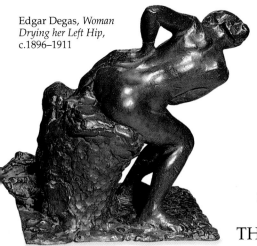

Degas' palette

DORLING KINDERSLEY
LONDON • NEW YORK • STUTTGART
IN ASSOCIATION WITH
THE ART INSTITUTE OF CHICAGO

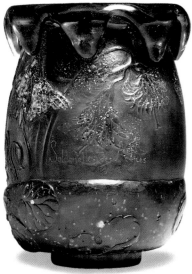

Vase by Emile Gallé

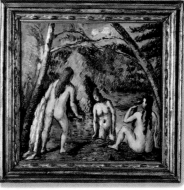

Paul Cézanne, *Bathers*, c.1879–82

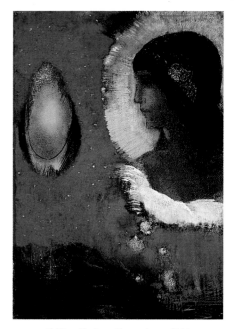

Odilon Redon, *Evocation*, c.1900

A DORLING KINDERSLEY BOOK

Project editor Phil Hunt
Art editor Mark Johnson Davies
Assistant editor Louise Candlish
Design assistant Simon Murrell
Senior editor Gwen Edmonds
Managing art editor Toni Kay
Managing editor Sean Moore
US editor Laaren Brown
Picture researchers Julia Harris-Voss, Jo Evans
DTP designer Zirrinia Austin
Production controller Meryl Silbert

First American edition, 1993

First published in the United States by
Dorling Kindersley, Inc., 232 Madison Avenue
New York, New York 10016

Library of Congress Cataloging-in-Publication Data

Wiggins, Colin
 Post-impressionism / by Colin Wiggins. -- 1st American ed.
 p. cm. -- (Eyewitness art)
 Includes index.
 ISBN 1-56458-334-1
 1. Post-impressionism (Art)--France. 2. Painting, Modern--19th
century--France. 3. Painting, Modern--20th century--France.
4. Post-impressionism (Art)--Europe. I. Title. II. Series.
ND547.5.P6W54 1993
759.05'6--dc20 93-7615
 CIP

Color reproduction by GRB Editrice s.r.l.
Printed in Italy by A. Mondadori Editore, Verona

Edvard Munch, *The Scream*, 1893

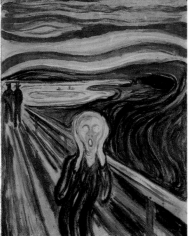

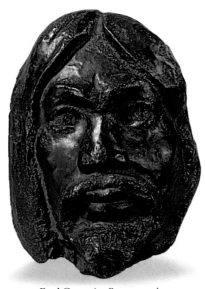

Paul Gauguin, *Bronze mask*

Art Nouveau brooch

Auguste Rodin,
Eve, 1881

Contents

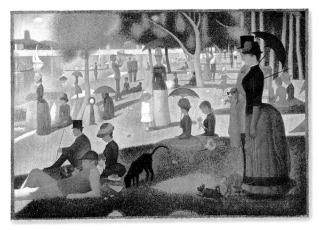

Georges Seurat, *A Sunday on La Grande Jatte*, 1884

What is Post-Impressionism?

THE TERM "Post-Impressionism" was coined in 1910, by the English art critic Roger Fry, as a convenient way of referring to the artists who came immediately after the Impressionists. These artists were centered in Paris and, for their own different reasons, rejected the principles of Impressionism. The term can also apply to much of the later work of the Impressionist artists themselves, who, as their careers developed, came to abandon many of the ideas that they had once subscribed to. The Post-Impressionist artists did not form into a coherent group or movement, and the term itself certainly does not refer to a "style" of painting. What the artists did have in common, however, was a desire to go beyond the world of external appearance that had been so important to the Impressionists.

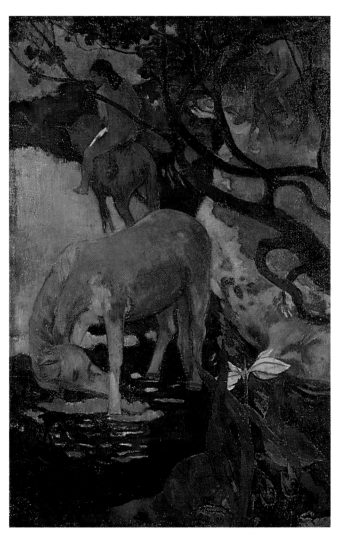

THE WHITE HORSE
Paul Gauguin; 1898; 55¼ x 36 in (140 x 91.5 cm)
Rejecting what he considered to be the corruption of modern society, Paul Gauguin left Europe and traveled to the South Seas (pp. 30–31), settling on the island of Tahiti. His colors became intense and anti-naturalistic – no longer descriptive, but evocative and exotic.

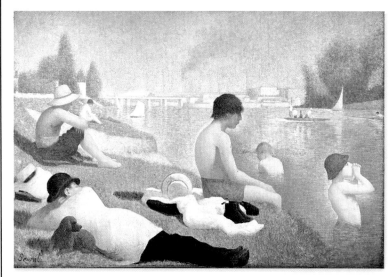

BATHERS AT ASNIERES
Georges Seurat; 1884;
78¾ x 118 in (200 x 300 cm)
Although this scene is from modern life, and therefore in accord with Impressionist subject matter, Georges Seurat (pp. 12–17) did not paint this work "on the spot." He posed models in his studio in a manner that compared with the grand classical paintings of the past. Furthermore, the monumental style negates the Impressionist concept of spontaneity.

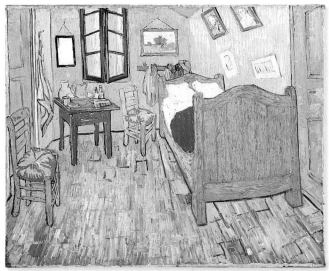

BEDROOM AT ARLES
Vincent van Gogh; 1889;
22¾ x 29¼ in (57.5 x 74 cm)
When Vincent van Gogh moved to the south of France, he experimented with the expressive and emotive effects of color (pp. 24–25). The results can be clearly seen – instead of being applied in small "Impressionist" brushstrokes, the color is used in bold areas of solid pigment. The result is a painting of mood and atmosphere, with the artist's personality strongly present.

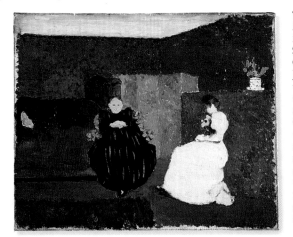

THE CHAT
Edouard Vuillard; 1892;
12¼ x 16¼ in (32.4 x 41.3 cm)
Strongly influenced by both Gauguin and the art of Japan, Edouard Vuillard was a central figure in the group of artists known as the Nabis (pp. 32–33). Characteristic of their work was an emphasis on pattern, with colors applied in a flat, almost abstract manner. The works often have a sense of mystery about them, with scenes being invested with a psychological charge.

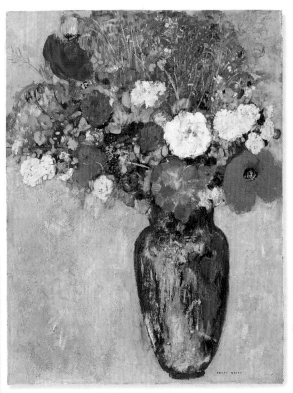

FLOWERS IN A VASE
Odilon Redon; c.1910; 7½ x 9¼ in (19 x 23.5 cm); oil on cardboard
The pastels of Odilon Redon, with their soft, delicate, and dreamlike colors, became much admired by the poets and writers of the Symbolist movement (pp. 28–29). They saw deep evocations of the unconscious in Redon's work, and were attracted to the idea that his art represented a superior kind of reality, rather than the merely visual world of the Impressionist artists.

LA MACARONA
Henri de Toulouse-Lautrec; 1893; 24¼ x 19¼ in (61.9 x 48.7 cm); oil, watercolor, and charcoal on paper
Henri de Toulouse-Lautrec (pp. 36–37) took his subject matter from Parisian lowlife rather than from the comparatively fashionable areas of Paris that had fascinated the Impressionists. La Macarona was a popular entertainer from the Moulin Rouge, and is the kind of character often portrayed in the artist's work. Toulouse-Lautrec's expressive use of line in this work is markedly anti-Impressionist.

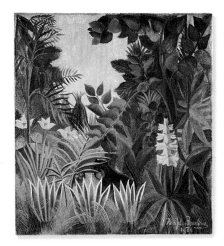

THE EQUATORIAL JUNGLE
Henri Rousseau; 1909; 55¼ x 51 in (140.6 x 129.5 cm)
The work of Henri Rousseau (pp. 48–49), with its naive style, was initially derided by most critics. Nonetheless, it gained him a small and influential group of admirers. Deeply imaginative, many of Rousseau's paintings show an exotic world set in fantastic jungles.

MONT ST. VICTOIRE
Paul Cézanne; 1904–6; 23½ x 28¼ in (60 x 72 cm)
Cézanne (pp. 10–11 & 46–47) avoided representations of the external world of Impressionism, with its transient light effects and concentration on surface appearances. He worked to convey the actual mass and substance of the landscapes and objects that he used as subject matter. He developed a tightly controlled brushstroke, painstakingly and slowly applied, that binds the composition together here in a way that conveys permanence and grandeur.

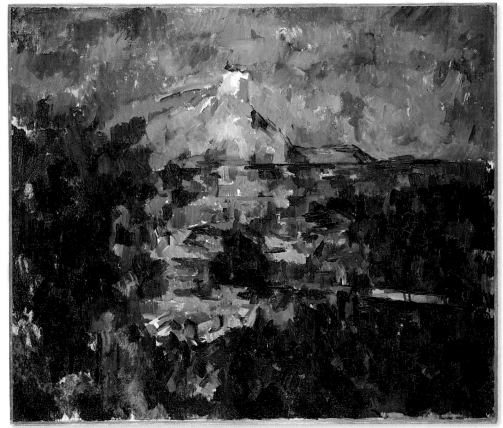

The end of an era

THE EIGHTH AND FINAL Impressionist exhibition took place in 1886, although by this time many of the works shown were no longer true to the original principles of Impressionism. Significant absentees included Claude Monet (pp. 58–59) and Auguste Renoir (pp. 42–43), two of the originators of a movement that, after more than a decade, had changed beyond recognition. In the beginning, the Impressionists had aimed to abandon the studio to make paintings outdoors using natural light, taking as their subject matter the modern life of the city and suburbs where they lived. This was done partly as a rejection of official "Salon" art, with its historical and allegorical subjects and its slick finish, but by 1886, Impressionism itself was being rejected – not just by the next generation of artists, but by many of its original supporters.

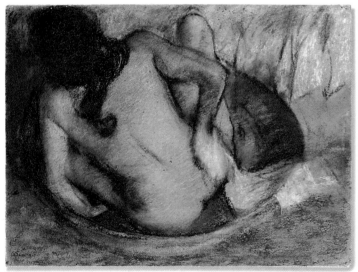

THE TUB
Edgar Degas; 1886; 23½ x 32¾ in (60 x 83 cm); pastel on board
Edgar Degas' lifelong interest in the artificial discipline of working directly from a model had always separated him from other Impressionists. This twisted pose is typical of his work both before and after the last exhibition.

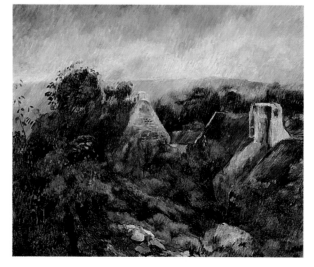

LA ROCHE GUYAN
Pierre-Auguste Renoir; c.1885; 18½ x 22 in (47 x 56 cm)
Renoir did not exhibit at the last Impressionist exhibition, having already decided that its theories resulted in work that was too frivolous. Influenced by Paul Cézanne (pp. 10–11 and 46–47), he began to adopt a tighter, more controlled manner of painting.

A Sunday on La Grande Jatte
GEORGES SEURAT
1884–86; 81¾ x 121¼ in (207.5 x 308 cm)
This painting was the most significant work of the 1886 exhibition. Seurat (pp. 12–17) transformed the Impressionist idea of the depiction of light by using modern scientific color theories, applying the paint in small dots of color that blend in the viewer's eye. This technique was called variously Pointillism or Divisionism (p. 62). Others saw it as a development of Impressionism, so it was also called Neo-Impressionism.

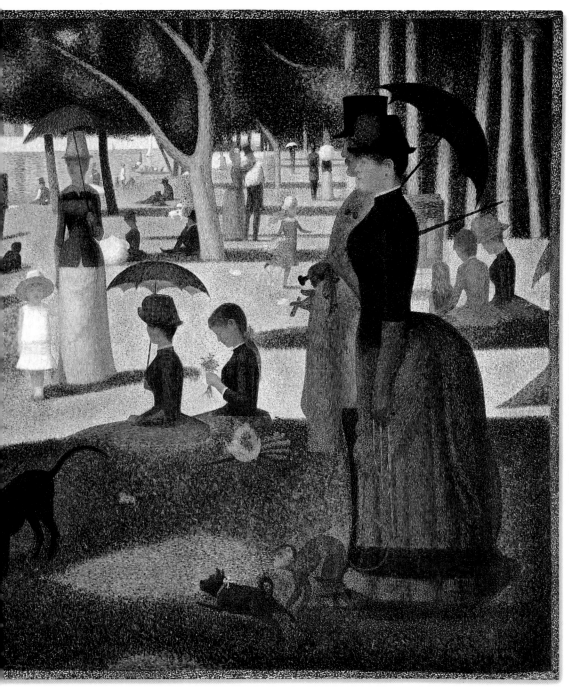

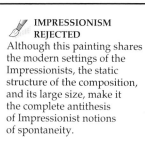 **IMPRESSIONISM
REJECTED**
Although this painting shares
the modern settings of the
Impressionists, the static
structure of the composition,
and its large size, make it
the complete antithesis
of Impressionist notions
of spontaneity.

A NEW SOLUTION
Several critics and
artists (among them the
Impressionist Pissarro, who
became a convert), saw
Seurat's methods as a positive
alternative to the fleeting,
insubstantial limitations
of Impressionism.

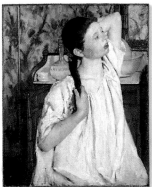

GIRL ARRANGING HER HAIR
*Mary Cassatt; 1886;
29½ x 24½ in (75 x 62 cm)*
Mary Cassatt's work has the
same classical approach
to draftsmanship that is
seen in the work of Degas
(pp. 56–57), with whom she
was very friendly. The precise
and careful drawing lacks
the spontaneity of a truly
Impressionist picture, and
the stillness and contrived
pose are both qualities
that deny the principles
of Impressionism.

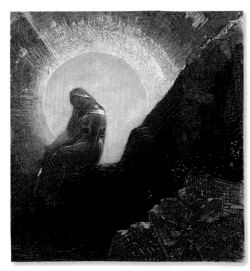

DAWN OF THE LAST DAY
*Odilon Redon; c.1880–85; 16¼ x 15¼ in
(41 x 38.8 cm); pastel, charcoal, and gouache*
The inclusion of work by Redon
in the last exhibition indicates just
how far the exhibition had come
from the ideas of Impressionism.
This particular work shows
Redon at his most visionary.

WOMEN BATHING
*Paul Gauguin; 1886;
25½ x 35½ in (65 x 90 cm)*
This was among the many
paintings that Gauguin showed
at the 1886 exhibition. The shapes
of the figures, the spaces between
them, and the undulating wave
all have abstract qualities that
were to become more evident
in his later work (pp. 30–31).

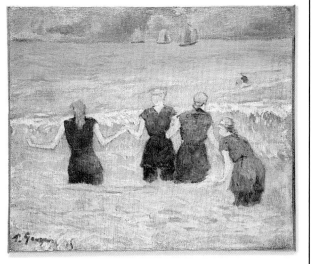

Young Cézanne

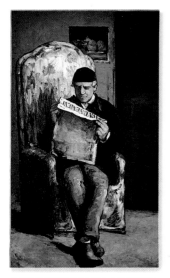

PORTRAIT OF LOUIS-AUGUSTE CEZANNE, ARTIST'S FATHER
Paul Cézanne; c.1866;
78¾ x 47¼ in (200 x 120 cm)
Cézanne's father, a respectable banker, was never sympathetic to his son's ambition to become a painter. This portrait, with its awkward perspective, was painted directly onto the wall of the family home.

Born in Aix-en-Provence in 1839, and a boyhood friend of the great realist writer Emile Zola, Paul Cézanne (1839–1906) began by creating work remarkable for its darkness, and for its romantic, often violent or erotic, mood. However, encouraged by the older artist Camille Pissarro (pp. 44–45), he adopted an Impressionist approach, exhibiting at the first Impressionist exhibition in 1874, and again at the third, in 1877. Cézanne's "Impressionism," though, must be considered in context, because he was already revealing a passion for structure and solidity that ultimately led him to reject the ideas of his Impressionist friends. He is one of the truly seminal modern painters, influential to the development of Cubism (p. 62), and inspiration for many of the great 20th-century artists.

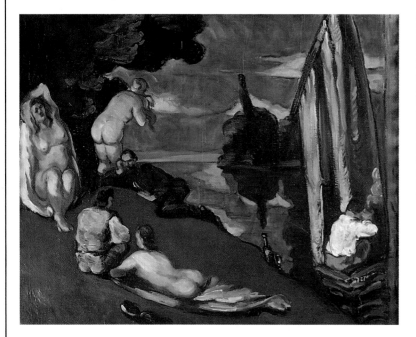

PASTORAL (IDYLL)
Paul Cézanne; 1870;
25½ x 32 in (65 x 81 cm)
Toward the end of his life, Cézanne worked on a series of great canvases representing the subject of bathers. Here, he shows an early interest in the subject, in a picture notable both for its bold handling and its mood of introspective melancholy. In a scene charged with mystery and latent eroticism, the reclining male is Cézanne himself.

Cézanne shows a definite change in style under the influence of Camille Pissarro (right)

THE YOUNG ARTIST
This photograph shows Cézanne together with Camille Pissarro. When Cézanne was aged 22, he briefly joined his father's bank. Following his father's wishes, he had been studying law at the University of Aix, but, in pursuit of his dream of becoming an artist, had enrolled at a drawing school. Despite their differences, Louis-Auguste did give his son some financial support while Paul attempted to establish himself in Paris. The artist's time there, however, was always difficult, and he often spent long periods back at the family home.

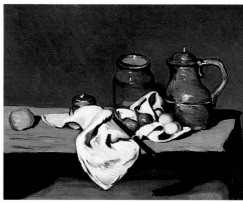

STILL LIFE: GREEN POT AND PEWTER JUG
Paul Cézanne; c.1869;
25½ x 32 in (64.5 x 81 cm)
Still life provided Cézanne with one of the cornerstones of his career. He was attracted to it because it allowed him to have some control over what he was painting and so impart a sense of order to it. The solidity and stability of this painting anticipates his later work.

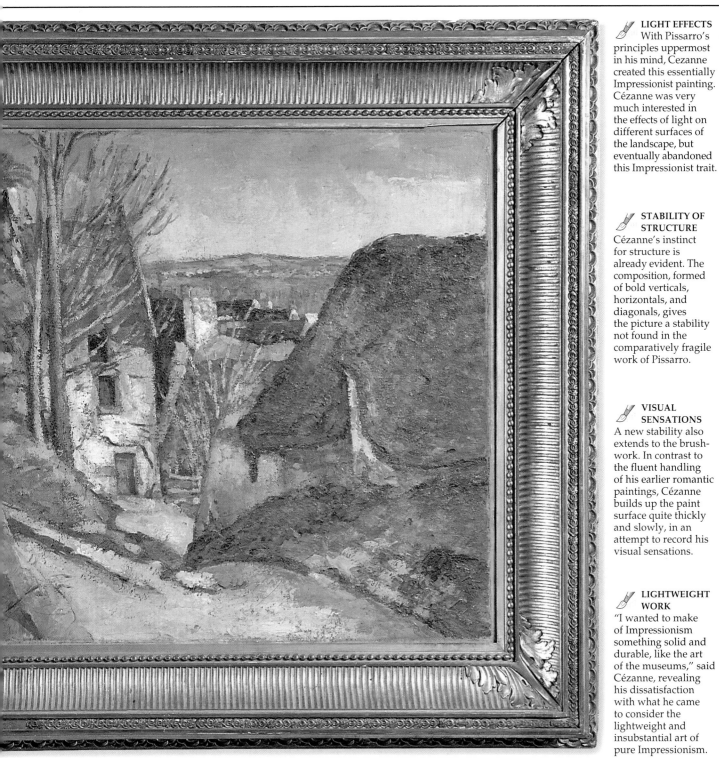

LIGHT EFFECTS
With Pissarro's principles uppermost in his mind, Cezanne created this essentially Impressionist painting. Cézanne was very much interested in the effects of light on different surfaces of the landscape, but eventually abandoned this Impressionist trait.

STABILITY OF STRUCTURE
Cézanne's instinct for structure is already evident. The composition, formed of bold verticals, horizontals, and diagonals, gives the picture a stability not found in the comparatively fragile work of Pissarro.

VISUAL SENSATIONS
A new stability also extends to the brush-work. In contrast to the fluent handling of his earlier romantic paintings, Cézanne builds up the paint surface quite thickly and slowly, in an attempt to record his visual sensations.

LIGHTWEIGHT WORK
"I wanted to make of Impressionism something solid and durable, like the art of the museums," said Cézanne, revealing his dissatisfaction with what he came to consider the lightweight and insubstantial art of pure Impressionism.

The House of the Suicide

PAUL CEZANNE *1872–73; 21¾ x 26 in (55 x 66 cm)*
Cézanne first met Camille Pissarro in 1861, and it was under his influence that he was to abandon his early romantic manner in favor of the painting of landscapes from nature. Nine years older than Cézanne, Pissarro proved to be a crucial influence on the younger artist, and the two became close friends, often accompanying each other on painting trips. Indeed, Cézanne's flirtation with Impressionism provided him with a love of painting outside (*"en plein air"*) that was to stay with him for the rest of his life. This particular painting was submitted to the first Impressionist exhibition in 1874, and depicts the house of a man who had hung himself in Auvers.

VILLAGE OF VOISINS
Camille Pissarro; 1872; 18¾ x 22 in (45 x 55 cm)
Painted directly from nature, this is the kind of work Pissarro was making when he met Cézanne. Essentially an Impressionist work, it is painted in front of the subject, and concentrates on capturing the transient effects of sunlight as it falls on different surfaces.

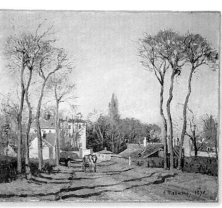

Classical Seurat

AFTER THE EXPERIMENTS of *La Grande Jatte*, Georges Seurat's (1859–91) next great composition, *Les Poseuses* (The Models), showed his continued interest in scientific color theories. This work also has significant references to classical art; these were used to create a complex and poetic allegory of the relationship between the traditional and the modern. The nude is one of the staple subjects of Western art, and the interior setting of *Les Poseuses* is in marked contrast to the outdoor (and therefore modern) setting of *La Grande Jatte* – part of which can be seen in the background. The models themselves bridge the gap between the old and the new. They seem to have stepped down from their roles in Seurat's modern masterpiece of contemporary life and undressed, abandoning their fashionable hats, parasols, and shoes, to take their place in the grand historical tradition of paintings of the nude.

CONTE CRAYON DRAWING
This early study for the central model (right) shows how the pose was originally conceived. The soft textures of conté crayon made it a favorite medium of Seurat's.

THE VALPINCON BATHER
Jean Ingres; 1808; 57½ x 38¼ in (146 x 97 cm)
This work is by Jean Ingres, the great French painter who was president of the Ecole des Beaux-Arts. The left-hand figure in Seurat's *Les Poseuses* is a direct quote from this celebrated work, which represented tradition and classicism.

STUDY FOR "LES POSEUSES": MODEL FROM BEHIND
Georges Seurat; c.1887–88; 9½ x 6¼ in (24 x 16 cm)
Seurat made a number of individual drawings and paintings, such as this one, for each of the three figures in *Les Poseuses*. Seurat has left nothing to chance, and this rigorous system for the precise planning of the final composition was a feature common to all of his major works.

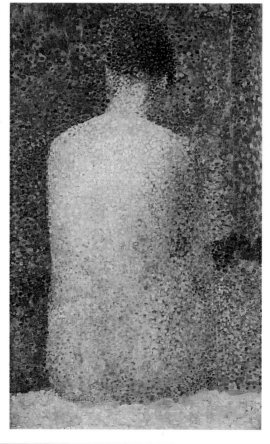

Les Poseuses
GEORGES SEURAT
c.1888; 15¼ x 19¼ in (39 x 49 cm)
This is the second and smaller of the two finished versions that Seurat made of this composition. Here, the "dots" are painted in a slightly looser manner, perhaps indicating that Seurat was reacting to criticism that his Pointillism sometimes seemed mechanical. The various preparatory studies that Seurat made for this painting are evidence of his desire to create "considered" art, in contrast to the "spontaneity" of Impressionism.

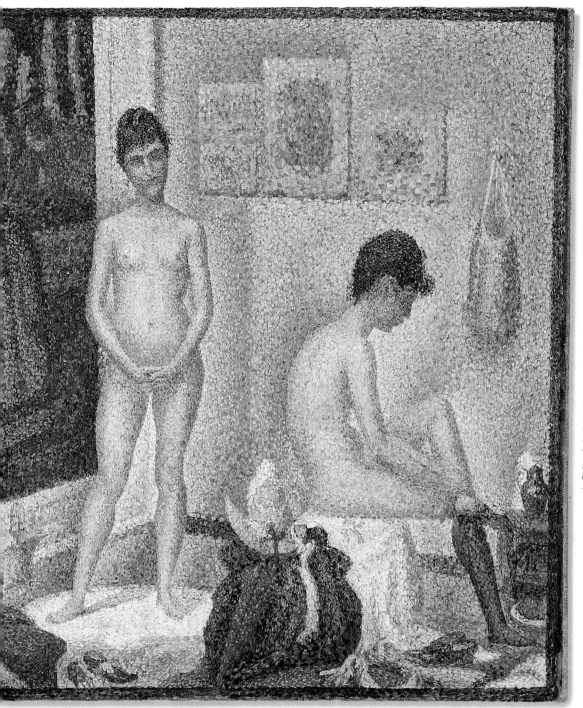

 ATTENTION TO DETAIL
The extreme artifice of this picture contrasts greatly with Impressionism, which Seurat had by now firmly rejected. Produced slowly and methodically in the studio, it is a painting that takes the tradition and process of painting itself as its subject.

THE FEMALE NUDE
The subject of the female nude was traditionally confined to mythological scenes. Seurat, however, painted his models "undisguised" and presented them as modern women whose nudity was justified by the very fact of their being in a painting.

SOLE MODEL
It is likely that Seurat used the same model for all three poses, thereby allowing us to see three views; back view, front view, and profile. This compares with the artistic experiments that Paul Cézanne (pp.10–11 and 46–47) was making at the same time.

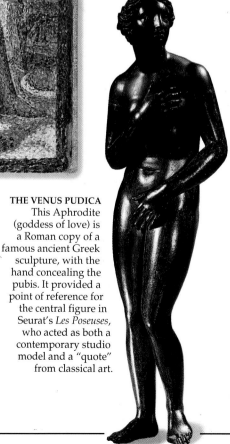

VENUS AT HER TOILETTE
A mosaic such as this 3rd-century Roman example is formed of tiny fragments of colored stone that, when seen from a distance, blend together to reveal the design. Seurat was interested in ancient art, and the overall effect of his Pointillism is similar to the tesserae (tiles) that make up mosaics (below).

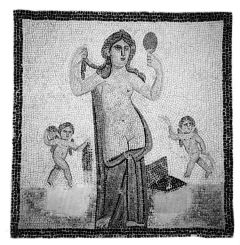

Detail from mosaic

Detail from *Les Poseuses*

THE VENUS PUDICA
This Aphrodite (goddess of love) is a Roman copy of a famous ancient Greek sculpture, with the hand concealing the pubis. It provided a point of reference for the central figure in Seurat's *Les Poseuses*, who acted as both a contemporary studio model and a "quote" from classical art.

The Pointillists

GEORGES SEURAT'S methods attracted much interest from a number of other painters, who collectively became known as the Neo-Impressionists. Inspired by the ideas of Charles Blanc, who held that "color, which is controlled by fixed laws, can be taught like music," Seurat and his allies made a detailed study of the theories of various scientific writers. They included Eugène Chevreul, who established that the appearance of any color can be radically altered by changing the colors placed immediately beside it. He also noted that colors appear to be at their most intense when positioned directly next to their complementaries (p. 63), and called his theory the "law of simultaneous contrast." It was from these ideas that the style known as Pointillism developed, whereby dots or points of color were placed next to one another on the canvas and mixed in the eye of the observer.

EUGENE CHEVREUL
Signac wanted to discuss Chevreul's theories with him, but by then the great theorist was almost 100 years old. He referred Signac to Jean-Auguste Ingres, his old acquaintance at the Ecole des Beaux-Arts, forgetting that Ingres had died some 20 years previously!

VARIETY OF STUDIES
In addition to his color wheel (far left), Chevreul made other studies of color, such as this plate showing the colors of the spectrum. Each color in the 1861 plate could be identified by a series of letters.

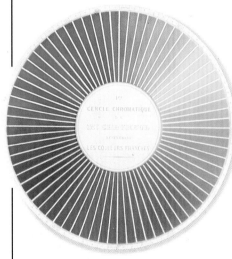

CHEVREUL'S "CHROMATIC CIRCLE"
Seurat made a color wheel similar to this one. For easy reference, complementary colors are shown immediately opposite each other, allowing the artist to make quick and accurate decisions about which colors to use.

SUNSET AT HERBLAY
Paul Signac; 1889–90; 22½ x 35½ in (57.1 x 90.2 cm)
Signac was the closest of Seurat's followers and the most vocal defender of his theories. After Seurat's death, it was he who assumed leadership of the Neo-Impressionist movement. The rich, atmospheric glow of this sunset is obtained by carefully controlled contrasts and harmonies of color. Each dot is applied according to scientific principles, to provide gentle and restful transitions of tone.

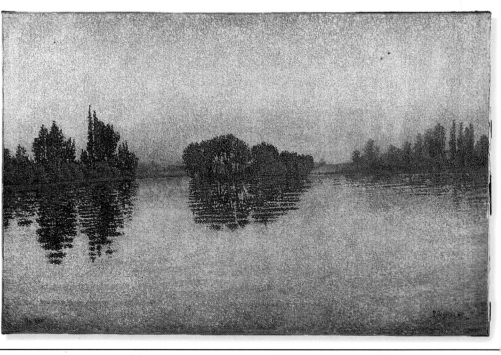

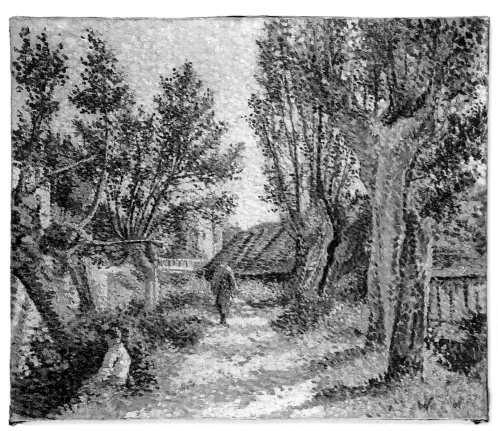

LANDSCAPE WITH WILLOW TREES
Maximilien Luce; 1887; 19¾ x 24¼ in (50 x 61.3 cm)
Luce had joined the followers of Seurat at the 1887 Salon des Indépendants, the first major showing of this steadily expanding group. Seurat was wary of newcomers such as Luce, who he saw as diluting the impact of his own work, but the best of these young artists all had their own approaches to his invention. The more romantically inclined Luce never used the scientific principles as rigorously as Seurat, applying his dots less meticulously. Here, patches of broken color animate the picture surface, resulting in a more spontaneous effect.

MULTICOLORED PRECISION
This detail shows how Luce has used every color of the spectrum, resulting in a flickering intensity and an almost nervous sense of vibration. Luce's delicate touch adds to this sensation. The artist preferred to work intuitively rather than strictly according to the "rules" of simultaneous contrast.

THE GLEANERS
Camille Pissarro; 1888; 25¾ x 32 in (65.5 x 81 cm)
It was as a result of Pissarro's encouragement that Seurat showed his *La Grande Jatte* (pp. 8–9) at the final Impressionist exhibition in 1886. Pissarro was the only artist to have shown at all of the Impressionist exhibitions since 1874, so his "conversion" to Divisionism (p. 62) was controversial. Pissarro saw Seurat's Neo-Impressionism as representing the kind of progress that Impressionism needed. He turned away from the scenes of modern life that had previously been so important to him, and chose instead to paint an idealized view of the countryside, investing the farmworkers with dignity and grace. However, by the beginning of 1890, he had returned to his earlier methods.

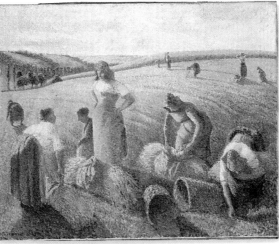

HENRI-EDMOND CROSS
Romantic in temperament, Cross (1856–1910) sought to express aspects of the imagination, which he attempted to show through the rational principles of Pointillism. Signac described him as "both a cold and methodical thinker and a dreamer, strange and troubled."

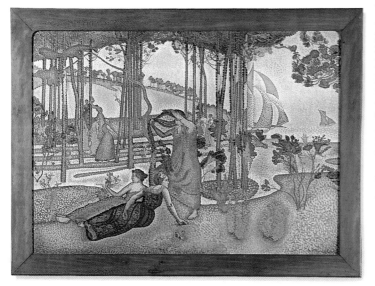

L'AIR DU SOIR
Henri-Edmond Cross; 1894; 45¾ x 64½ in (116 x 164 cm)
In the hands of Cross, Pointillism received perhaps its most romantic handling. In this work, made three years after the death of Seurat, the colors are applied in a Pointillist manner, but the subject matter takes on a greater significance. The painting appears to glow with a mysterious golden light, which, combined with the classically draped figures who seem to float through an idealized garden, evokes an illusory sense of the unreal.

Geometric Seurat

Seurat's approach to geometry was deeply influenced by the ideas of Charles Henry, a mathematician interested in the science of aesthetics (the study of concepts such as beauty and taste). Henry attempted to codify a set of "laws" relating to color and line, of the same nature as those which govern music. Other scientific writers were proving equally important for Seurat, as he sought to perfect those ideas that he had been experimenting with in *La Grande Jatte*. For his subject matter he turned to themes already treated by the Impressionists, scenes of city life and popular entertainment, but he endowed them with qualities of mystery and mood that endeared him to the Symbolists (pp. 28–29). Despite his early death at the age of 31, during a diphtheria epidemic in 1891, his work was to have a profound and long-lasting influence.

GRAVELINES
Georges Seurat; 1890; 6¼ x 9¾ in (16 x 25 cm)
Seurat applied the same principles of geometrical simplification to his seascapes as he did to his city subjects. The abstract purity of these paintings anticipates many of the developments of 20th-century art.

Parade de Cirque
GEORGES SEURAT
1887–88; 39¼ x 59 in (100 x 150 cm)
This gaslit scene shows the Cirque Corvi, a traveling circus that performed in Paris. Seurat's admiration of ancient Egyptian art, and his desire to give a relieflike appearance to his pictures, combine with his meticulous analysis of color and line to create a picture of stillness and silence – qualities that seem to contradict the subject of a noisy performance.

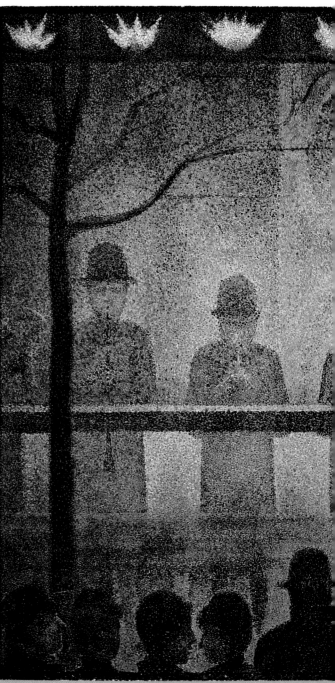

LE CHAHUT (STUDY)
Georges Seurat; 1889–90; 9½ x 6¼ in (22 x 16 cm)
Here Seurat roughly works out his color system and pictorial rhythms before refining them in the finished work (right) – using the much tighter brushwork of Pointillism.

LE CHAHUT
Georges Seurat; 1889–90; 66½ x 54¾ in (169 x 139 cm)
According to Charles Blanc (p. 14), lines affect the mood of a painting. Those that go up express happiness, while lines that go down express sadness. Here Seurat forces everything up, creating a celebration of riotous noise.

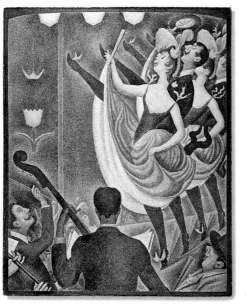

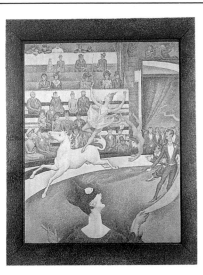

CIRQUE
Georges Seurat; 1890–91;
72¼ x 59 in (185 x 150 cm)
In this, Seurat's last major work, his
experiments with both the decorative
and psychological effects of upwardly
thrusting movements are taken to
extremes. The jagged rhythms and
harsh dynamism are obtained by his
careful choice and juxtaposition of
both color and lines.

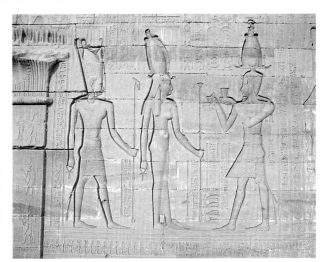

EGYPTIAN RELIEF
This relief is from the wall of the
eastern facade of the Temple of
Hathor in Dendara, Egypt. Seurat's
interest in Egyptian painting and
sculpture is evident in his stylized
figures and the geometric nature
of some of his compositions.

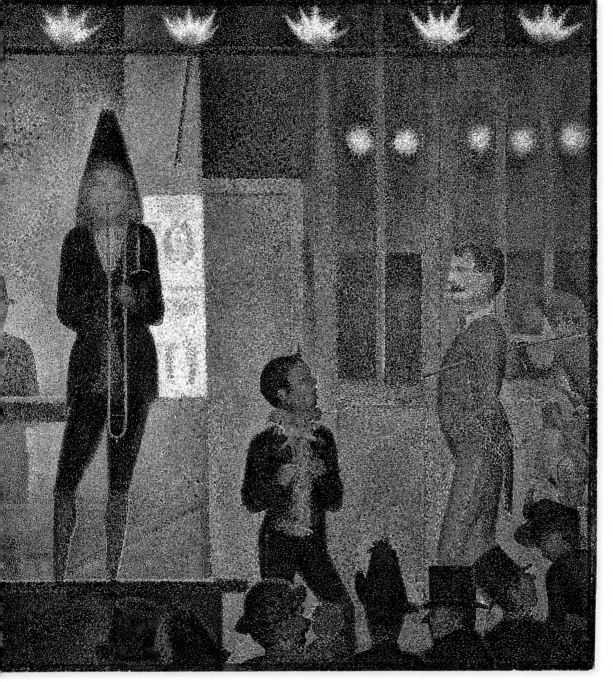

A GEOMETRIC PAINTING
Finely applied
dots of contrasting
colors add a sense of
vibration and sparkle
to the picture. The
addition of a narrow,
painted border around
the composition, often
present in Seurat's
work, emphasizes
the geometric nature
of the painting.

THE RHYTHM WITHIN
Repeated shapes,
such as the luminous
gas jets along the
top, or the hats of
the spectators and
performers, introduce
"musical" elements of
rhythm and interval
to the painting.

A CRITIC'S OPINION
Roger Fry (pp. 6–7)
wrote of this painting,
"However precise
and detailed Seurat
is, his passion for
geometricizing never
deserts him – enclosed
so completely, so shut
off in its partition,
that no other relation
than a spatial and
geometrical one is
any longer possible."

Van Gogh in Paris

VINCENT VAN GOGH (1853–1890) arrived in Paris at the beginning of 1886 to stay with his art-dealer brother Theo. Until then, his work had been produced in Holland, or in Antwerp, where he had lived as a student. His paintings were dark and somber, with none of the vibrant color with which he was to become associated. Theo was friendly with many artists of the Impressionist group and Parisian avant-garde, such as Pissarro, Bernard, and Gauguin, and it was through him that Vincent soon became part of that group. His work altered radically; he began to experiment with color, taking as his new subject matter the boulevards, restaurants, and characters of modern Paris. Impressionism, though, was an exploratory style for van Gogh, who encountered it on his way to developing his own unique style of painting.

STILL LIFE WITH HORSE'S HEAD
Paul Gauguin; c.1886;
19¼ x 15 in (49 x 38.5 cm)
One of the artists van Gogh met in Paris was Paul Gauguin (pp. 22–23 & 30–31), a character who was to play a very significant part in his life. This still life dates from about the time of van Gogh's arrival in Paris, and shows that Gauguin had a brief flirtation with the ideas of Neo-Impressionism.

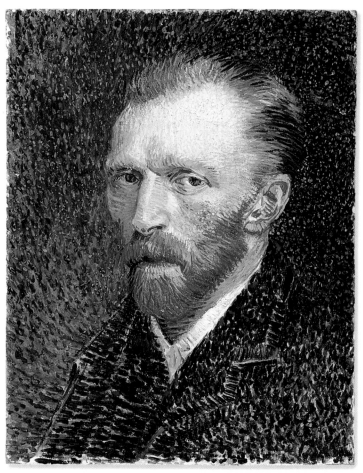

SELF-PORTRAIT
Vincent van Gogh; 1886–87; 16¼ x 12¾ in (41 x 32.5 cm)
One of the first exhibitions that van Gogh saw after his arrival in Paris was the final Impressionist show of 1886 (pp. 8–9), which included Seurat's *La Grande Jatte*. Van Gogh made nearly 30 self-portraits while in Paris, and here the broken color on the artist's face and jacket, and more particularly the "dots" of the background, reveal his admiration for Seurat.

Van Gogh and Gauguin show influences of both Impressionism and Pointillism in this period

THE TERRACE OF THE MOULIN, LE BLUTE FIN, MONTMARTRE
Vincent van Gogh; c.1886;
17¼ x 13 in (43.5 x 33 cm)
The bold application of paint in this picture of a Montmartre landmark shows an increasing confidence on the part of the artist. His interest in color contrasts is evident in the use of the complementaries (p. 63) blue and orange. The two lovers sitting together also act as "complementaries."

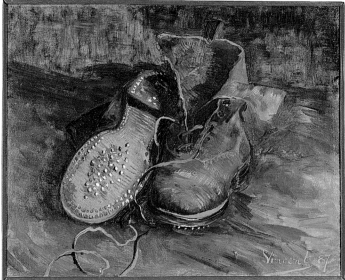

PAIR OF BOOTS
Vincent van Gogh; 1887; 13½ x 16¼ in (34 x 41 cm)
The color contrast in this painting – the reddish orange of the sole of the boot is the complementary of the background blue – shows van Gogh experimenting with color theory (pp. 14–15). His interest in color was evident in his letters to Theo; he once wrote, "I don't mind whether my color corresponds exactly, as long as it looks beautiful on the canvas." Shoes were a popular subject in realist art, possibly symbolizing the hard life of the laborer.

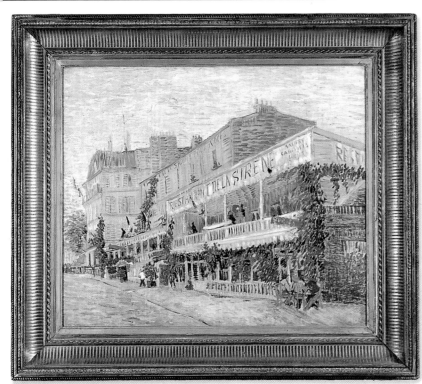

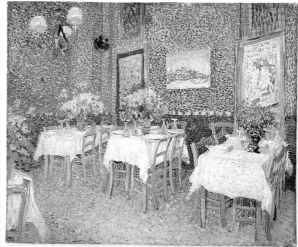

INTERIOR OF A RESTAURANT
Vincent van Gogh; 1887; 21¼ x 25½ in (54 x 64.5 cm)
Van Gogh added a personal touch to this interior by including one of his paintings, *The Park at Asnières*, on the restaurant wall.

THE RESTAURANT DE LA SIRENE, ASNIERES
Vincent van Gogh; 1887; 21½ x 25¼ in (54.5 x 65.5 cm)
The subject and style of this work are deeply influenced by the Impressionists. The rapid application of paint gives the scene an atmospheric sparkle.

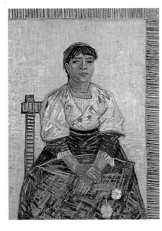

THE ITALIAN WOMAN
Vincent van Gogh; 1887–88; 32 x 23¾ in (81 x 60 cm)
The flat, boldly colored background, clearly derived from Japanese prints, marks a step away from Impressionism – here van Gogh experimented with areas of solid pigment. This was the first of a number of portraits where van Gogh added a flower in the composition along with the subject.

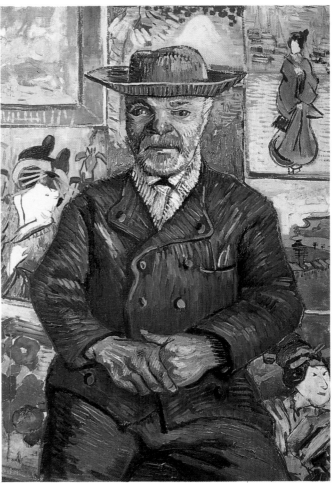

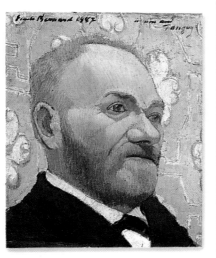

PORTRAIT OF PERE TANGUY
Emile Bernard; 1887;
14¼ x 12¼ in (36 x 31 cm)
Tanguy sold artists' materials and would often accept paintings as payment, building up a stock of works by many artists, including Pissarro and Cézanne. Emile Bernard, who painted this portrait, was a close friend of van Gogh, from the time they first met in Paris until van Gogh's suicide.

JAPANESE PRINT
Van Gogh's move away from the broken colors of Impressionism, toward a bolder and flatter handling of paint, was partly prompted by his interest in, and deep love of, Japanese prints. He had his own collection of these prints and also became fascinated by the way of life of the Japanese artists.

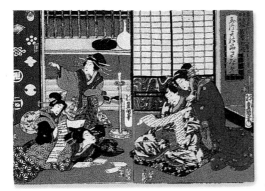

PORTRAIT OF PERE TANGUY
Vincent van Gogh; 1887–88; 25½ x 20 in (65 x 51 cm)
Père Tanguy was committed to many of the avant-garde artists in Paris, and was a great support to van Gogh in particular. This portrait shows him seated before a screen of Japanese prints, of which he had a small stock. Tanguy shared the enthusiasm of van Gogh and the other avant-garde artists of the time for the art of Japan.

New light on the city

INDUSTRIAL SEINE
This charcoal drawing, *Bridge at Courbevoie*, was drawn by Georges Seurat in 1886. Courbevoie was an expanding industrial suburb of Paris on the river Seine (not unlike Asnières), and Seurat went on to complete a painting of the same title the following year.

MODERN CITY life had been one of the principal subjects of Impressionist painting, but the artists had tended to show only the fashionable areas. The Post-Impressionist generation, following the example of the realist novelists like Emile Zola and the Goncourts, began to take more interest in the less salubrious industrialized areas of Paris. Seurat's *Bathers at Asnières* (p. 6) was a depiction of a working-class suburb and, against a background of worsening urban deprivation, many other artists of this time seemed to respond to the city as a place of bleak isolation. Nevertheless, as a subject, it continued to attract many painters and inspired some of the most memorable works of the period.

ILLUMINATED PARIS
Late 19th-century advances in illumination created new lighting effects in the city, which were of interest to artists such as Louis Anquetin (below).

Iron Bridges at Asnières

EMILE BERNARD
1887; 18 x 21½ in (45.9 x 54.2 cm)
This style of painting is known as Cloisonnism (p. 62), a method invented by Bernard and his friend Louis Anquetin. Named after a type of decorative and highly colored enamelwork called cloisonné, its characteristics are the bold areas of flat color and the hard outlines between shapes. The bridges in the painting are the same as those in Seurat's *Bathers at Asnières*.

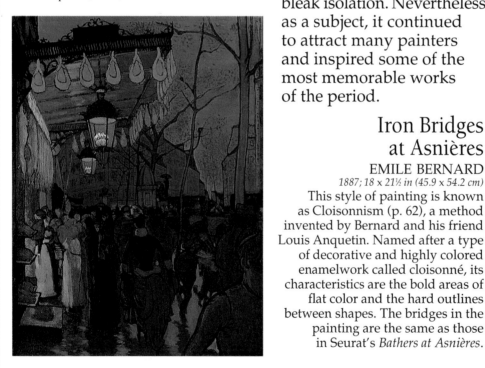

STREET SCENE –
FIVE O'CLOCK IN THE EVENING
Louis Anquetin; 1887; 27¼ x 21 in (69 x 53 cm)
Through their study of Japanese prints and stained glass windows, Louis Anquetin and Emile Bernard consciously devised the Cloisonnist style of painting – as a rejection of the Impressionist idea of representing the external world. The artificial style of the painting emphasizes the artificial nature of the subject, and the colors that Anquetin used skillfully evoke the gathering, gaslit dusk. Bernard said of Anquetin that "he took on the task of becoming the painter of his period through depicting purely modern Parisian subjects."

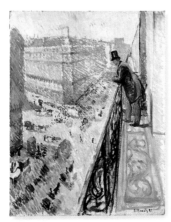

RUE LAFAYETTE
Edvard Munch; 1891;
36¼ x 28¾ in (92 x 73 cm)
The Norwegian painter Edvard Munch (pp. 52–53) was initially attracted to Paris to see the works of the Impressionists, and indeed, this painting illustrates their influence. The vibrance of this work is in contrast with *Evening on Karl Johan's Street* (p. 52), a more threatening city scene that Munch painted two years later.

Camille Pissarro; 1897;
21 x 25½ in (53.3 x 64.8 cm)
Although he had a long
career as an Impressionist,
Pissarro was always eager to
experiment, both with new
ways of painting and new
subjects. This shimmering
painting, made from a hotel
room window, takes as its
subject the city by night,
bathed in artificial light.

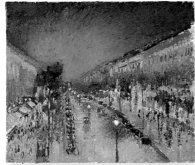

THE SQUALID CITY
As these newspapers show,
Paris had an ongoing problem
of the most squalid poverty,
which encouraged riots among
the poor and often instigated
violent political action. The
anarchist movement, whose
sympathizers included the
poet Stéphane Mallarmé
(p. 29) and painters such as
Paul Signac and Camille
Pissarro, was responsible
for several bombings.

**THE ISOLATION
WITHIN**
The two silhouetted
figures hurry on their
way, anxious to reach
their destination.
Keeping their backs
to us, they seem to
symbolize the enforced
anonymity and
isolation suffered by
so many city-dwellers.

FLAT COLOR
The style is
antinaturalistic
and therefore anti-
Impressionist. The
large and solidly
applied areas of color
are a total denial of the
Impressionist manner
of painting that Seurat
had used in his view
of the scene (p. 6).

**INFLUENCE
ON GAUGUIN**
In 1898, Bernard
traveled to Pont-Aven
in Brittany (pp. 22–23).
There, his style of
painting had a deep
effect on Gauguin,
who soon produced
his startling
masterpiece, *The
Vision After the
Sermon* (p. 23).

**AN ARTIFICIAL
SCENE**
The only hint of
natural life in this
painting is the
scrubby, worn patch
of grass at the bottom.
Everything else is
artificial, manmade,
and soulless. Even the
river itself has been
forced into artificial,
geometric shapes.

Gauguin and Pont-Aven

PAUL GAUGUIN
Here the artist is seen wearing his favorite Breton jacket.

IN 1883, AGED 35, Paul Gauguin (1848–1903) left his job on the Paris stock exchange to become a full-time painter, initially as an Impressionist under Pissarro's influence. Dissatisfied with the need to record appearances, however, he abandoned naturalism and in 1886 traveled to the village of Pont-Aven in Brittany, seeking a more primitive subject matter and a style of painting not bound by traditional constraints. Of Spanish-Peruvian origin, Gauguin spent four childhood years in Lima and often referred to his "savage blood." Thus, the "primitivism" of Brittany, with its strong traditions of folk art, provided him with inspiration to "synthetize" – that is, to simplify and express the colors and forms of his subjects in a style both bold and antinaturalistic.

A NEW MOVEMENT
In this drawing by Emile Bernard, entitled *Synthetisme – a Nightmare*, Bernard places himself between his fellow painters Schuffenecker and Gauguin – claiming for himself a role in the new movement known as Synthetism (p. 62).

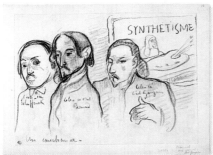

TROPICAL VEGETATION, MARTINIQUE
Paul Gauguin; 1887; 45¾ x 35 in (116 x 89 cm)
In 1887 Gauguin traveled to the Caribbean island of Martinique, seeking a chance to paint an exotic landscape without the "civilization" that he was rejecting. The primitive lifestyle of the native population and the variety of the tropical vegetation fascinated him. Gauguin's intense colors are based on reality, but exaggerated, resulting in a painting of a luxuriant landscape, with distance and space implied – although the overall effect is mainly flat.

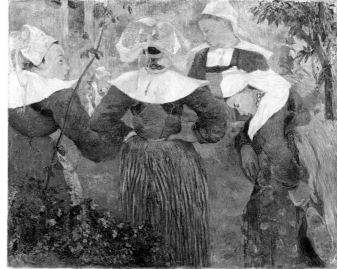

FOUR BRETON WOMEN
Paul Gauguin; 1886; 28¼ x 35½ in (72 x 90 cm)
Gauguin's attention to the patterns made by the costumes of these peasant women represents a rejection of old pictorial conventions such as perspective and space. The artifice of the style that he has developed is emphasized by placing three of the women in strict profile. Unlike an Impressionist picture, *Four Breton Women* was not painted outside, but carefully composed from several preparatory studies.

LANDSCAPE, SAINT BRIAC
Emile Bernard; 1889; 21¼ x 25¼ in (53.9 x 64.1 cm)
Bernard was one of the community of artists based in Pont-Aven. His Brittany landscapes represent the topography by means of large, flat, patternlike areas.

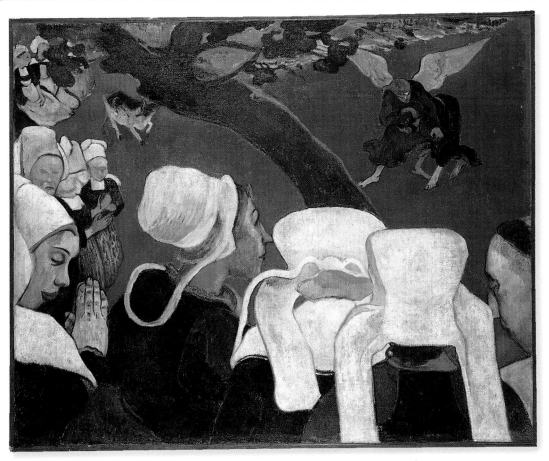

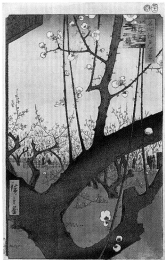

HIROSHIGE PRINT
Gauguin shared the Impressionists' interest in the art of Japan. Hiroshige's *Flowering Plum Tree* (1857) provided the device of the tree flatly cutting the composition in two, and the Japanese style of abruptly cropping elements was also used by Gauguin. Japanese art was only one aspect of his desire to learn from the art of other cultures – an appoach that had been traditionally regarded as "primitive."

THE VISION AFTER THE SERMON
Paul Gauguin; 1888; 28¾ x 36¼ in (73 x 92 cm)
This painting, based on a story from the Book of Genesis, tells of Jacob wrestling for a night with an angel. The tree divides the picture into two; on the left is a group of Breton women with a priest, and on the right is the vision of the story they are experiencing. The radical distortions of color and the denial of perspective make this one of Gauguin's most important paintings.

ALBUM PAINTING
Basohli; 1730–35; 9 x 13 in (23 x 33 cm)
The emotive use of color, in paintings such as this one, was a well-established tradition in India for centuries. It was echoed by Gauguin in his attempts to use color to express spiritual values. His fascination for all forms of "foreign art" led him to seek it out wherever he could.

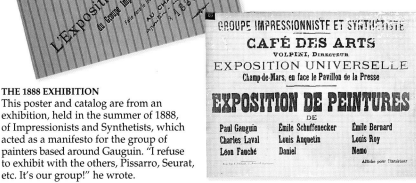

THE 1888 EXHIBITION
This poster and catalog are from an exhibition, held in the summer of 1888, of Impressionists and Synthetists, which acted as a manifesto for the group of painters based around Gauguin. "I refuse to exhibit with the others, Pissarro, Seurat, etc. It's our group!" he wrote.

LANDSCAPE IN THE BOIS D'AMOUR (THE TALISMAN)
Paul Sérusier; 1888; 10¾ x 8½ in (27 x 21.5 cm)
Sérusier was one of several artists influenced by Gauguin at Pont-Aven. This painting was the result of a lesson given to Sérusier by Gauguin. "How do you see those trees? They are yellow. Well then, put down yellow. And that shadow is rather blue. So render it with pure ultramarine. Those red leaves? Use vermilion." The picture's mystical title emphasizes the vital role that it had in disseminating Gauguin's theories.

Van Gogh and landscape

WHEN VAN GOGH WAS LIVING in Paris with his brother (pp. 18–19), his difficult personality and increasingly eccentric behavior caused severe problems for the more conventional and respectable Theo – problems of which Vincent was painfully aware. He became interested in seeking a life for himself elsewhere and, inspired by stories that he had heard of Japanese artists living apart from society in "colonies," it became his ambition to establish an artists' colony and invite other painters to come and join him. Accordingly, in February 1888 he left Paris and settled in the Provençal town of Arles, in the south of France. It was in the sunbaked landscape around Arles that he made the final break with Impressionism and (still supported financially by Theo) where he painted many of his most memorable and exciting canvases.

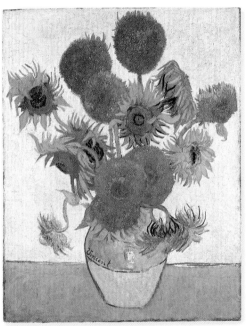

SUNFLOWERS
Vincent van Gogh; 1888; 36¼ x 28¾ in (92 x 73 cm)
This energy-packed painting is one of several versions that van Gogh made as a decoration for Paul Gauguin's room. Gauguin joined Vincent in Arles, arriving in October 1888.

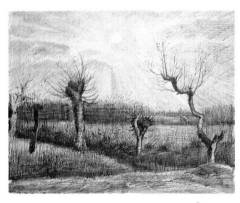

EARLY LANDSCAPE
Working directly from the landscape was firmly rooted in the Dutch tradition. This drawing in pen and ink, *Landscape with Pollarded Willows* (1884), was made before van Gogh left Holland to join Theo in France.

LANDSCAPE WITH A HAWKING PARTY
Philips de Koninck; c.1674; 52¼ x 63 in (132.5 x 160.5 cm)
This is a typical composition by the Dutch landscape painter, who was particularly dear to van Gogh. The sharp horizon and the gentle diagonals on the ground seem to be echoed in van Gogh's work – one Dutchman emulating another, some 200 years later.

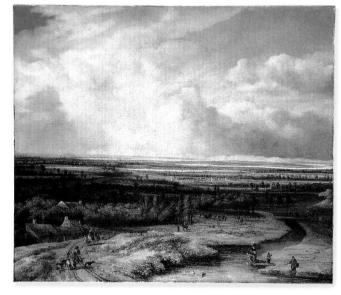

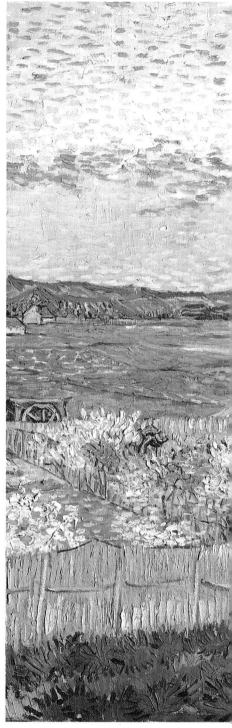

Peach Blossom in Le Crau

VINCENT VAN GOGH
1889; 25½ x 32 in (65 x 81 cm)
Van Gogh found the bright colors of the Provençal landscape immensely cheering. He set about responding to them in a series of paintings (including this one) that, although rooted in Impressionism, go far beyond its boundaries in expressive power. The artist's enthusiasm was conveyed in a letter to Theo: "Here my life will become more and more like a Japanese painter's, living close to nature."

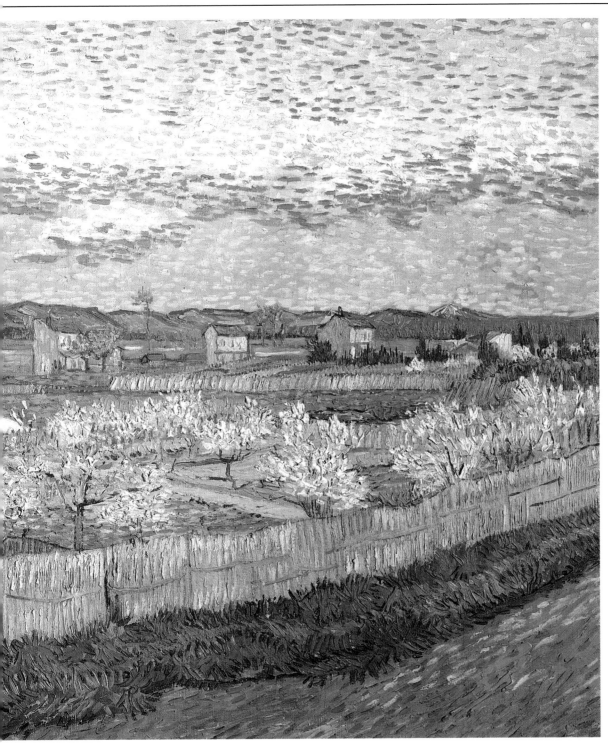

JAPANESE SCENE
This view of an orchard in the spring, with its fruit trees a mass of colorful blossoms, is one that held a particular attraction for van Gogh, as it reminded him of Japanese prints.

NATURAL EXHILARATION
The dots of paint on the sky are no longer applied with Neo-Impressionist principles or precision. Now they convey the excitement and exhilaration that the artist felt when sitting in the spring sunshine, recording the scene.

UNIQUE STYLE
The paint is applied thickly, in van Gogh's characteristic impasto, giving the picture surface an animation and energy of its own. Oil paint in tubes was a new development; the tubes allowed the artist to squeeze his color straight onto the canvas.

JAPAN IN THE SOUTH
For van Gogh, the landscape of Provence became a realization of his quest to find his "Japan in the south." His choice of colors brilliantly evokes the freshness and purity of the air on a bright, clear spring day.

DIFFERENT STROKES
This drawing, *Landscape of Montmajour with Train* (1888), was made at Arles using a reed pen. The different types of strokes that van Gogh uses for the different parts of the landscape are a graphic equivalent to the impasto that he was using in his paintings of the time.

THE THERAPY OF DRAWING
After becoming a voluntary patient in the asylum at St. Rémy (pp. 30–31), a vital part of van Gogh's treatment consisted of making drawings and paintings. This pen drawing, *Weeping Tree in the Grass* (1889), was done directly from nature in the asylum garden, the spiky linework conveying tension and despair.

Van Gogh's death

WHILE THE EXACT nature of van Gogh's illness may never be known, its results included a dreadful incident in December 1888, in which he mutilated his own ear and presented part of it to a prostitute. He was treated in the local hospital before becoming a voluntary patient in the asylum at St. Rémy, where he was diagnosed as an epileptic. In May 1890, his brother Theo arranged for him to move to Auvers-sur-Oise, an hour from Paris, where two months later the 37-year-old artist committed suicide. Van Gogh's work of this period is not Impressionist in any way. Instead, he uses intensified color and highly charged brushwork to express his response to nature in a way that works directly on the emotions of the viewer. Aspects of his work began to interest many of the Symbolists (pp. 28–29), as they attempted to convey the same kind of response to the mystery of nature.

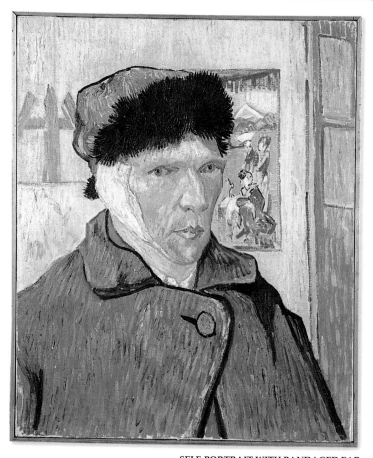

SELF-PORTRAIT WITH BANDAGED EAR
Vincent van Gogh; 1889; 23½ x 19¼ in (60 x 49 cm)
Van Gogh's illness was characterized by sudden breakdowns, during which he was incapable of any rational act. However, these punctuated long periods of lucidity. It is wrong to consider him "mad," as the remarkable objectivity of this self-portrait shows. It was made during his convalescence in Arles, and has one of the Japanese prints that he loved so much in the background. Every brushstroke of color is applied meticulously; there is nothing to indicate anything but the utmost self-control. It is an extraordinary record of suffering and sadness, rendered even more poignant by its stoic air of detachment.

HOUSES WITH THATCHED ROOFS
Vincent van Gogh; 1890; 28 x 36 in (72 x 91 cm)
Van Gogh arrived in the village of Auvers on May 20, 1890, and the picturesque buildings helped to inspire a last burst of activity. The undulating rhythms of the trees, as they seem to sway slowly in the breeze, are continued in the clouds and landscape below. Even the buildings seem to want to join in with this motion in a picture that is one of the artist's most lyrical works.

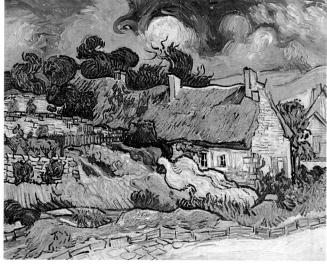

MADAME GACHET IN THE GARDEN
Vincent van Gogh; 1890; 18 x 21¾ in (46 x 55.5 cm)
Both Dr. Gachet and his wife were friends of Cézanne, Pissarro, and several other artists. They lived in Auvers and were a great support to van Gogh during his last few months, although they could have done nothing to prevent his tragically early death.

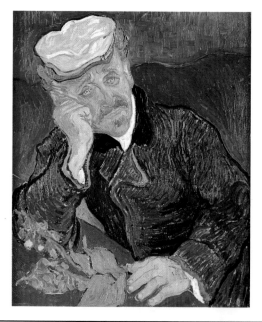

PORTRAIT OF DR. GACHET
Vincent van Gogh; 1890; 26¾ x 22½ in (68 x 57 cm)
A feature of many of the paintings van Gogh produced during his brief time at Auvers is the swirling pattern made by the brushstrokes. Here Dr. Gachet leans on his elbow, while his cap, coat, and the foxglove in the glass are drawn hypnotically into van Gogh's pictorial rhythms.

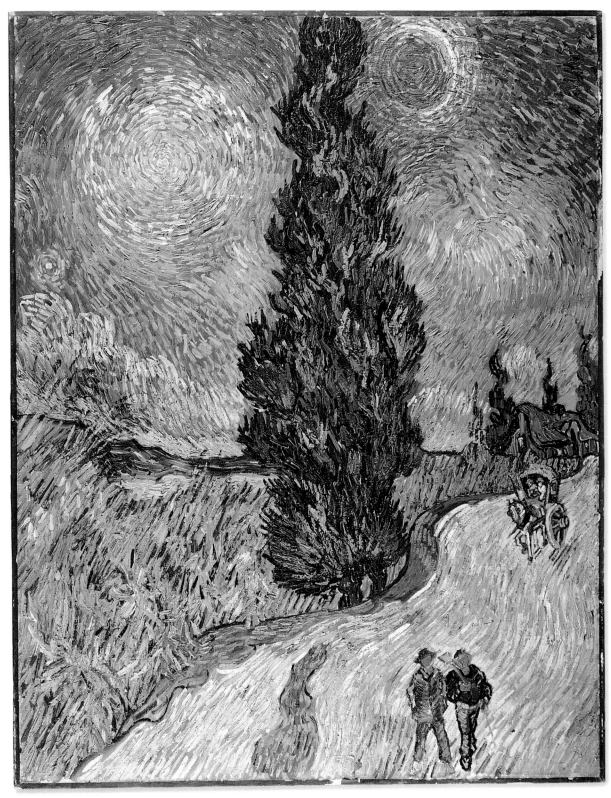

RELIGIOUS ALLEGORY

The beautiful sense of vibration in the sky is achieved by applying broken and contrasting colors in circular sweeps. The picture has a rich glow that van Gogh hoped the viewer would associate with the haloes seen in religious paintings.

PROVENÇAL EVENING

A dark cypress tree is set against a shimmering evening sky in which is seen a star and a crescent moon. Below, some tiny figures seem to be dwarfed by the grandeur of nature as they make their way along a road.

SYMBOLIC CYPRESS

The cypress was traditionally seen as a symbol of death, and it was Aurier who linked van Gogh's work with that of the Symbolists (pp. 28–29). The moon and the stars are two other motifs often found in van Gogh's St. Rémy compositions.

RELENTLESS RHYTHM

Everything in this picture is subordinated to a relentless, swirling rhythm, giving it a sense of growth and organic life. It marks an absolute break with the old "descriptive" style of the Impressionists and instead is powerfully expressive of the forces of nature.

Cypress Against a Starry Sky

VINCENT VAN GOGH *1890; 36¼ x 28¾ in (92 x 73 cm)*

This painting, one of the last he produced in Provence, was given as a present to the critic Albert Aurier, who had given van Gogh great encouragement by writing the first serious article on him, in the *Mercure de France*. He wrote of van Gogh, "He is not only a great painter, enraptured with his art, with his palette, and with his nature, he is also a dreamer, a fanatical believer ... who lives on ideas and illusions."

THE ARTIST'S PALETTE
Van Gogh's output of work during his last few weeks at Auvers was prodigious: the artist often completed several canvases in one day. It is thought that this palette dates from those final weeks; its vivid and smeared pigments may indicate the speed with which he worked – he produced about 70 works in Auvers.

The Symbolists

STEPHANE MALLARME
"I think that there should be only allusion … To suggest it, that is the dream …" said Mallarmé in 1891. A friend of many painters, he was a key Symbolist figure.

SYMBOLISM BEGAN as a literary movement, with poets and writers attempting to express a deeper reality than that represented by the merely optical world of the Impressionists. Fantasy, emotions, and intuitive experience became their favored subjects, as they sought to reject the rational and visible in favor of mystery and imagination. Different writers supported different painters, seeing in their work a visual equivalent to their own poetry. This denial of things material also had its political implications, and many of the poets and the artists who came to be associated with the Symbolists sympathized openly with the anarchist movement. In 1886 the poet Jean Moréas published the "Symbolist Manifesto," looking to older writers such as Charles Baudelaire and Stéphane Mallarmé to provide inspiration.

PORTRAIT OF HUYSMANS, WRITER
Jean Forain; 1878; 21¾ x 17¼ in (55 x 44 cm); pastel
Huysmans was initially a friend of the naturalist writer Emile Zola, before switching allegiance to the Symbolists. Then his most vigorous support was for Gustave Moreau and Odilon Redon.

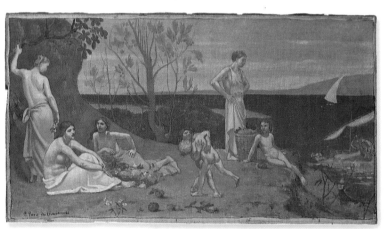

PAYS DOUX
Puvis de Chavannes; 1882; 10 x 10¾ in (25.7 x 27 cm)
Puvis had made his career mainly from large-scale public commissions, of pictures that represented an ideal world based upon antiquity. Admired by many, including Bernard and Gauguin, he was a precursor of the Symbolists.

REDON LITHOGRAPH
This lithograph by Odilon Redon is called *Perhaps Nature First Tried Eyes on Flowers* (1883). In 1868 he wrote, "Some people insist upon the restriction of the painter's work to what he sees. Those who remain within these narrow limits commit themselves to an inferior goal." Redon epitomized the fantastical side of art taken up by some of the Symbolists.

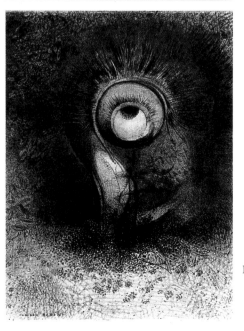

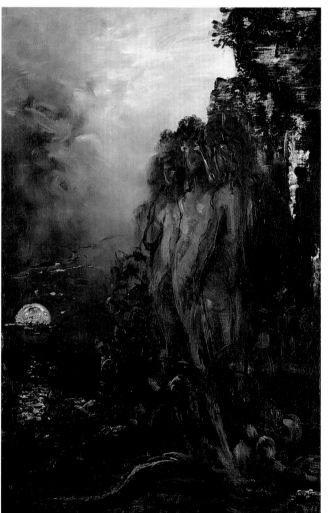

THE SIRENS
Gustave Moreau; c. 1890–95; 36½ x 24½ in (93 x 62 cm)
Reclusive by nature, Moreau had steadfastly ignored Impressionism to create an art, with themes of sex and death, that endeared him to the Symbolist writers. The sirens were figures from legend who lured sailors onto the rocks with the fatal beauty of their songs. This painting, laden with symbolic meaning, represents them with somber colors.

LE SILENCE
Georges Lemaire; c.1900; 20½ x 7¼ in
(52 x 18.3 cm); lapis lazuli, jasper, agate, opal
Lemaire was a successful sculptor,
metalworker, and decorative artist.
This piece has no definitive meaning;
it is left to the spectator, guided
by the title, to interpret. The pose
and expression are suggestive of
mysterious, priestly rituals, and
the nature of the materials used –
including lapis lazuli, opal, agate, and
other semiprecious materials – adds
a further evocative sense of the exotic.

CONDOLENCES
Georges Seurat, who composed
this charcoal drawing, never claimed
links with the Symbolists, but
became a figure of much interest
to them. His experiments with the
evocative possibilities of line and
color provided parallels with the
poets' theories of verse and phrase.

THE LOSS OF VIRGINITY
Paul Gauguin; 1890–91;
33½ x 51¼ in (90.2 x 180.2 cm)
After his return to Paris from Brittany
(pp. 16–17), Gauguin became friendly
with the Symbolist writers, particularly
Mallarmé. A pale, fragile, naked girl
lies in a fertile Breton landscape, with
a fox (which Gauguin said he included
as the "Indian symbol of perversity").

1890 CATALOG COVER
This catalog is for the fourth
exhibition of paintings by
the Impressionists and
Symbolists in Paris. The
inclusion of the word
"Impressionist" in the
title had nothing to
do with what is now
understood by the term.
Since the word had
become associated
with new and radical
art, they chose the
name to emphasize
their own different
brand of art.

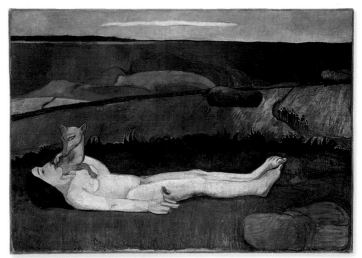

EVOCATION
Odilon Redon; c.1905;
20½ x 14¼ in (52 x 36.3 cm); pastel
The title of this is deliberately vague;
"My drawings are not intended to
define anything: they inspire," wrote
Redon. "They lead, like music, into an
ambiguous world where there is no
cause and no effect." The saturated
richness of the colors gives an exotic,
hallucinatory effect to the pastel.

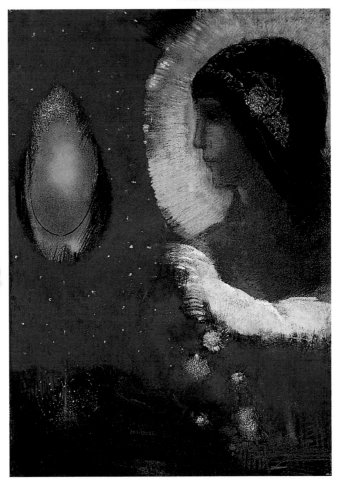

IMAGINARY PORTRAIT
OF PAUL GAUGUIN
Odilon Redon; 1904; 26 x 17¼ in (66 x 44 cm)
Redon and Gauguin were great
admirers of each other's work.
Gauguin said of his friend, "The artist
himself is one of nature's means … to
me, Redon is one of those chosen for
the continuance of its creations."

Gauguin in Tahiti

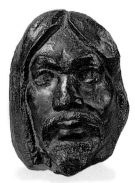

MASK OF A SAVAGE
A bronze cast of an original plaster mask, this "primitive" head was made by Gauguin in an attempt to appeal to collectors of exotic art.

In June 1891, having taken the decision to abandon Europe, Gauguin arrived in Tahiti. Sadly, the Tahiti of popular imagination had already largely disappeared under the influence of a prudish French administration. Yet, although he endured difficult circumstances, the time he spent there had a profound effect on his art. After two years he returned to France, where he produced *Noa-Noa*, an illustrated account of his voyage. He left Europe for the last time in July 1895, and returned to Tahiti, where he lived in poverty and poor health. Still in search of his primitive ideal, he finally moved to the remote Marquesas Islands in 1901, where he died in 1903, aged 54. Both his work itself, and his serious interest in the art of so-called "primitive" people, were to leave a lasting legacy.

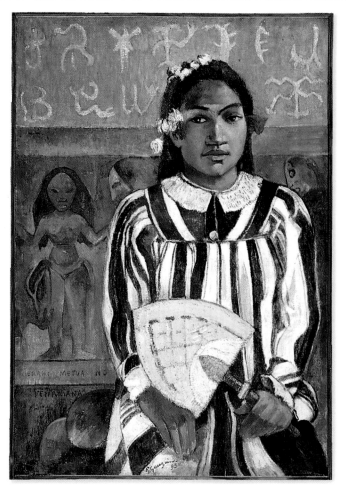

MERAHI METUA NO TEHAMANA
Paul Gauguin; 1893; 30 x 20½ in (76 x 52 cm)
The title, "Tehamana has Many Parents," refers to the belief that many Tahitians were descended from the goddess Hina (depicted in the background), and to the custom of foster parents "sharing" children with their real parents. Tehamana, wearing a European missionary dress, sits before a pagan relief, thereby symbolizing the union between East and West, and past and present. The writing at the top is Gauguin's approximation of the indecipherable script of the ancient Polynesians.

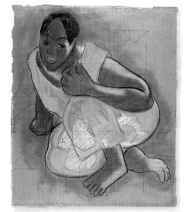

PREPARATORY DRAWING
This pencil and pastel drawing is entitled *Crouching Tahitian Woman* (1892) and has been carefully squared-up for use as a preparatory study for a painting. It indicates Gauguin's practice of carefully working out his compositions before executing them on canvas.

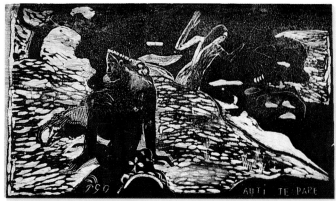

AUTI TE PAPE
This woodcut, the title of which means "The Fresh Water is in Motion," was made to illustrate *Noa-Noa*, Gauguin's own romanticized account of his first two years on Tahiti. The crude printing technique that he uses evokes a powerful sense of primitive art.

NOA-NOA ILLUSTRATIONS
Tehamana was a 13-year-old Polynesian girl who, according to Gauguin in *Noa-Noa*, became his "bride" and taught him about the customs and myths of the ancient Tahitian religion. The book is illustrated throughout with prints, watercolors, and collages.

MAHANA NO ATUA
Paul Gauguin; 1894;
27 x 36 in (68.3 x 91.5 cm)
This painting is a fusion of the ideas and imagery that Gauguin had been preoccupied with for many years. Translated as "Day of the God," it shows a stylized deity who presides over a sacred domain featuring a pool made up of entirely abstract shapes and colors.

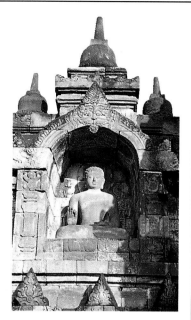

BOROBUDUR BUDDHA
This Buddha, here seen in traditional cross-legged pose, provided a direct source for the pose of Gauguin's *Idol With a Pearl.*

IDOL WITH A PEARL
Gauguin based the facial features of this wooden sculpture on the faces of the local Polynesian population, but used a pose based on Eastern representations of Buddha. He had seen such objects in Paris, at the Exposition Universelle of 1889, and was apparently fascinated by their symbolism.

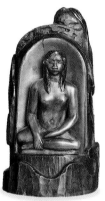

Idol with a Pearl

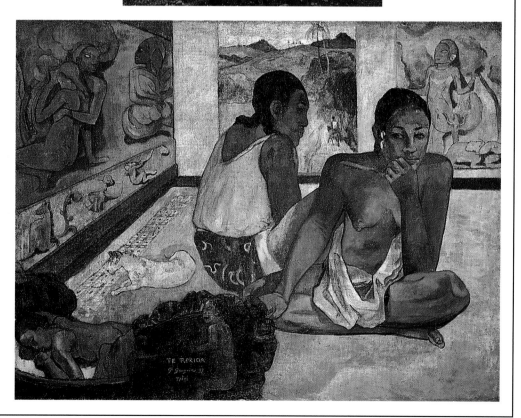

TEMPLES AT BOROBUDUR
Gauguin owned several photographs of this 9th-century Buddhist temple complex in Java. Its sculptures provided the basis for his representation of the deity in *Mahana no Atua* (above, left), showing that it was not just Tahitian imagery that interested Gauguin, but as many forms of non-Western art as he could find.

TE RERIOA
Paul Gauguin; 1897; 37½ x 51¼ in (95.1 x 130.2 cm)
A child, watched over by two women, sleeps in a cradle that is decorated with carved wooden figures. A sculpted frieze, with representations of primitive pagan deities, is visible on two of the walls. The title of this painting – "The Dream" – adds an extra layer of ambiguity. Is this Gauguin's dream, the child's dream, perhaps the woman's, or even that of the ancient gods themselves? The frieze is equally hard to interpret, being formed of both animals and figures in stylized ritualistic poses.

The Nabis

THE FORMATION OF THE GROUP who called themselves the Nabis (Hebrew: "prophets") was triggered by Paul Sérusier's return to Paris from Pont-Aven, in October 1888, where he had been working with Gauguin. He brought with him his painting *The Talisman* (pp. 16–17), which deeply impressed several young artists, foremost among them Pierre Bonnard, Edouard Vuillard, and Maurice Denis, who saw the potential in Sérusier's new style for producing an art with a deeper meaning. The Nabi group had a shared admiration for both the work of Gauguin and the art of Japan. They also felt a disillusionment with the values of Parisian life and adopted a lifestyle that included various aspects of Oriental mysticism, ritualistic meetings, and a desire to achieve an expression of spiritual depth in their art. Several members of the group were attracted by theosophy (p. 63), a philosophy that combined elements from all the major world religions, and Paul Ranson even consecrated his studio as a "temple."

Catholic Mystery
MAURICE DENIS
1890; 20 x 30¼ in (57 x 77 cm)
A devout Catholic, Denis was concerned about the continuation of religious art in the Paris of his time. This composition is "borrowed" from traditional paintings of the Annunciation and shows the Virgin Mary reading a holy book held by a contemporary priest, emphasizing the Christian message to modern life.

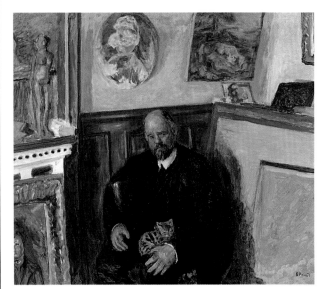

AMBROSE VOLLARD WITH HIS CAT
Pierre Bonnard; c.1924;
38 x 43¾ in (96.5 x 111 cm)
Vollard was an art dealer and friend of many artists. This portrait, made after the Nabis had ceased to exhibit together, shows the fragile delicacy of Bonnard's work.

CHRIST AND BUDDHA
Paul Ranson; 1890;
26¼ x 20¼ in (66.7 x 51.4 cm)
By combining a symbol of Christianity with images of Buddha, a Hindu lotus, and an Arabic inscription, Ranson confirms his interest in Theosophy. A complete rejection of naturalism (p. 63) characterizes his work.

SYMBOLIC LILY
The lily on the window-sill is a traditional symbol of the Virgin Mary and, together with the glowing quality of the light, brings an atmosphere of sanctity to the painting.

ABSTRACT DETAIL
The decorative aspect of the painting is highly important, as Denis seeks to express his meaning through the abstract qualities of line, shape, and color.

PROFOUND DENIS
In 1890, Denis published a statement that was to have great significance in the next century, as painting developed toward pure abstraction: "A picture, before being a war horse, a nude, or some anecdote, is essentially a surface covered with colors arranged in a certain order."

ITALIAN INFLUENCE
As well as being influenced by recent artistic developments, Denis was also interested in the work of early Italian painters. He particularly appreciated the work of Fra Angelico, the 15th-century monk, whose work had a devout simplicity that appealed to Denis.

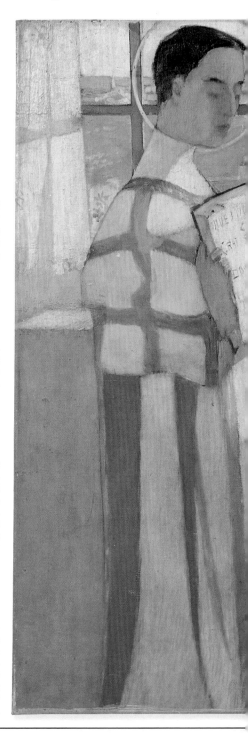

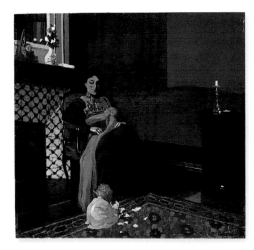

MOTHER AND DAUGHTER
Edouard Vuillard; 1892;
18¼ x 22¼ in (46.5 x 56.5 cm)
A painting of pattern rather than form,
the bold flatness of the shapes made
by the figures has its own abstract
life. Vuillard's mother was a dress-
maker, and his childhood was spent
surrounded by highly patterned fabrics.

MADAME VALLOTON AND HER NIECE
Felix Valloton; 1899–1900; 19¼ x 20¼ in
(49.2 x 51.3 cm); oil on cardboard
A poetic sense of mystery transforms
an everyday scene into a kind of sacred
ritual. The flat, darkly shadowed areas
contrast with the patterned surfaces
of the carpet, while the flowers and
candlestick add a quiet note of sanctity.

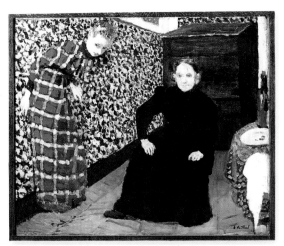

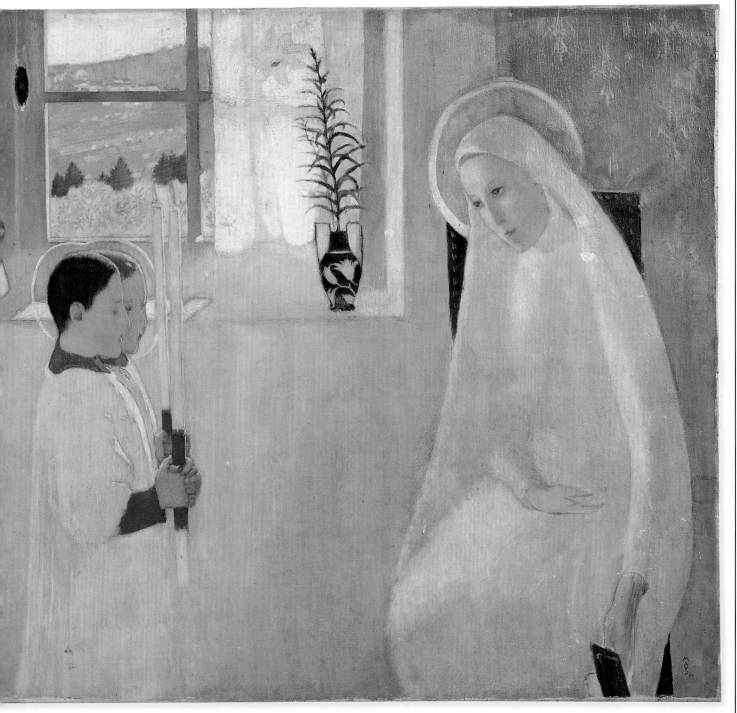

Thirst for publicity

THE STORY OF Henri de Toulouse-Lautrec (1864–1901) is one of the most fascinating in the history of art. Lautrec was deformed and crippled, the unfortunate result of both the inbreeding of his aristocratic background (he was descended from the medieval Counts of Toulouse) and a childhood accident. In later life his poor health was exacerbated by syphilis and alcoholism. His remarkable energy, however, allowed him to produce a substantial body of work and he became much in demand as a poster designer. His passion for the cabaret theaters and their characters (pp. 36–37) coincided with the perfection of a new printing technique for the rapid production of posters and programs. Lithographic posters became highly sought-after collector's items, and individual prints were sold at high prices. Sets of lithographs were specially commissioned – as they gained the status of works of art in their own right.

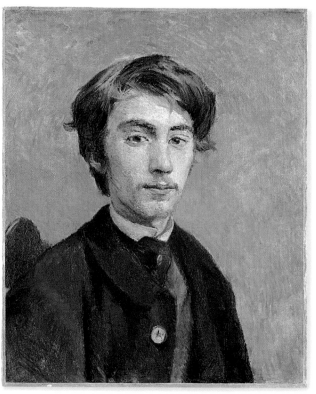

PORTRAIT OF EMILE BERNARD
Henri de Toulouse-Lautrec; 1885; 21¼ x 17½ in (54 x 44.5 cm)
According to the sitter himself, this sensitive portrait of a fellow artist was made after 20 sittings and Toulouse-Lautrec still "couldn't make the background fit the face." Lautrec and Emile Bernard were students of the academic artist Fernand Cormon, and it was at this period in his career that Lautrec's "Impressionist" painting style developed. This picture was made shortly after Bernard had been expelled from Cormon's class.

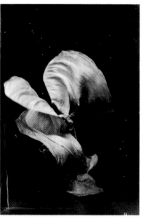

AN AMERICAN ABROAD
Loie Fuller was an American dancer who performed at the Folies-Bergère (p. 36). Her act consisted of various routines, during which she would twirl large veils around her head and body while, offstage, a team of electricians illuminated her with a display of colored lights. Her performance was seen as a kind of Symbolist dance.

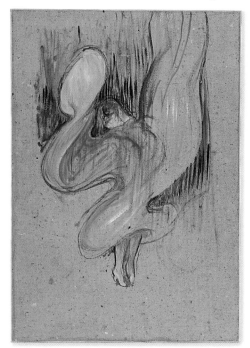

PORTRAIT OF LOIE FULLER (STUDY)
Toulouse-Lautrec; 1893; 25 x 17¾ in (63.2 x 45.3 cm); oil on cardboard
Toulouse-Lautrec was captivated by the performances of Loie Fuller. The rapid swirls of this energetic drawing, made as a study for a lithograph, capture the energy and motion of her dance. The low viewpoint brilliantly conveys the sensation of sitting in the front row of the theater.

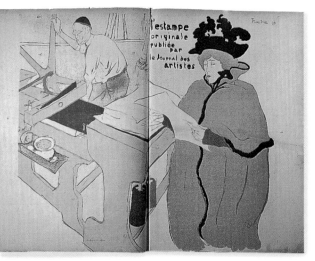

COVER OF "L'ESTAMPE ORIGINALE"
Toulouse-Lautrec designed this as the cover of a quarterly publication of original prints by many leading artists of the day (including Bonnard, Vuillard, Anquetin, and Denis). Seen operating the press is Père Cotelle, a brilliant technician who collaborated with many artists in the printing of their work.

LAUTREC AND HIS SUBJECT
Like his hero Degas (pp. 56–57), Toulouse-Lautrec was attracted to the lowlife subject of the brothel. This staged photograph shows him with a naked model in front of the painting *Au Salon*.

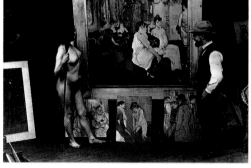

MAY MILTON POSTER
This poster was designed by Toulouse-Lautrec for a tour of the United States by May Milton and was therefore never used in France (although it was available to collectors). Printed in five colors, it is one of Lautrec's most "Japanese" inventions. The roundel at the bottom left is the artist's monogram, made up of his initials (HTL), but designed to look like a Japanese character.

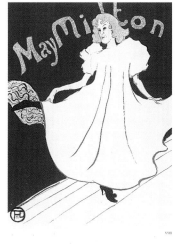

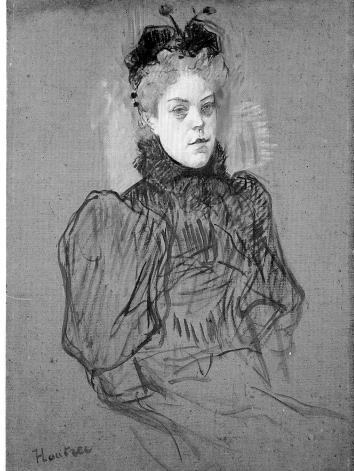

PORTRAIT OF MAY MILTON
Toulouse-Lautrec; 1895; 26 x 19¼ in (65.9 x 49.2 cm); oil and pastel on cardboard
May Milton was an English dancer who, after starting her career in a troupe, soon established herself as a successful solo artiste, performing in Paris, London, and New York. Made in one or perhaps two sittings, this portrait shows, in the sketched manner of the painting of the body, the expressive power of Lautrec's line – the technique that he exploited so well in his posters. The finished part of the painting, May Milton's face, reveals his ability as a remarkable portrait painter.

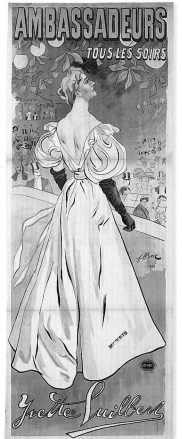

POSTER OF YVETTE GUILBERT
"With her white dress, her black gloves and her crazed features, she looks like a wisp of a genie from an ether bottle," wrote Edmond de Goncourt of the café-concert singer Yvette Guilbert. The poster was designed by Bac, one of the most successful graphic artists of the period.

DIVAN JAPONAIS
The Divan Japonais cabaret took the highly fashionable Japanese style as the theme for its decor. Lautrec's flat, bold colors and the cropped design used for this poster are devices taken from Japanese prints. In the foreground is the celebrated dancer Jane-Avril, while behind her, Yvette Guilbert (above) is recognizable from her trademark black gloves – despite the fact that her head is not visible.

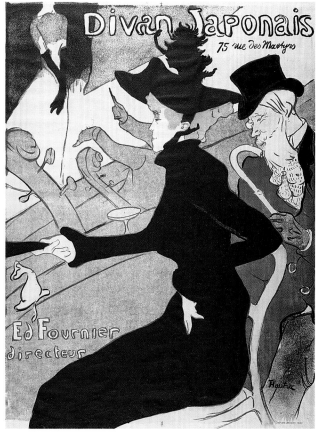

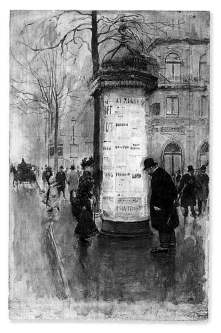

PARISIAN POSTER SITES
Poster sites, such as the one shown here, became a characteristic feature of the Parisian scene during the 1880s and '90s. As their popularity increased, a whole industry grew up around the design and manufacturing of posters, and virtually every street corner had its own site where they could be displayed.

Lautrec's technique

ALTHOUGH TOULOUSE-LAUTREC was renowned for his 350 or so posters and graphic works, he also produced more than 750 oil paintings. The subjects were often drawn from the seedy Parisian lowlife of Montmartre brothels, cafés, and music halls in which he immersed himself. As a result, a painting such as *At the Moulin Rouge* provides us with an insight into the Paris of the 1890s that Toulouse-Lautrec evoked so well. His paintings serve as fascinating and remarkable documentation of a unique piece of late 19th-century Parisian history, a period when café society was brimming with intrigue, vitality, and color.

Raw sienna Raw umber Ivory black

Emerald green Chrome yellow Chrome orange

ARTIST'S PALETTE
By the 1870s, the rapid development of the chemical industry and the discovery of chromium had radically increased the range of colors that were available to artists. The first generation of artists to benefit from this were the Impressionists, followed by the Post-Impressionists. New yellows and oranges could now be used in combination with the traditional earth pigments (siennas and umbers).

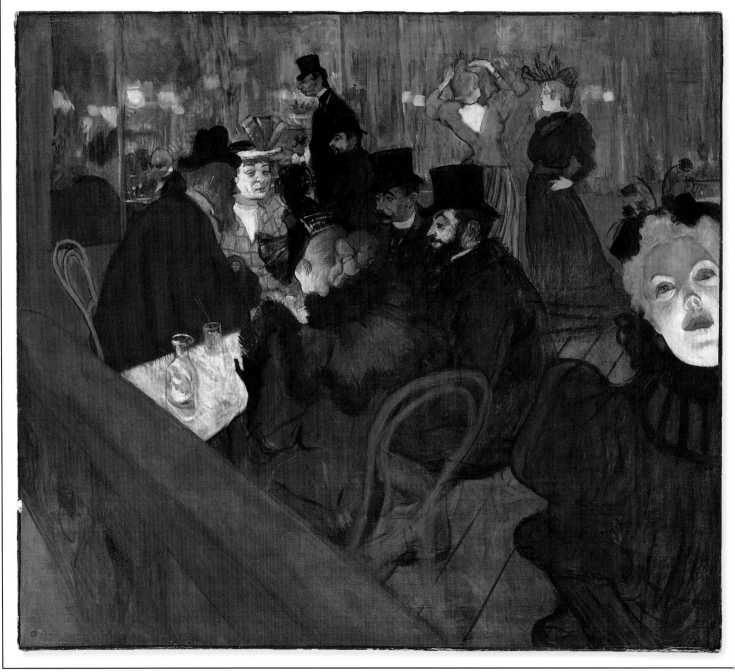

SHIMMERING LAMPS

The gaslight that illuminates the room sparkles in the mirrors covering the walls. The artist uses broken, unfocused brushmarks to represent the reflections, applied with a looseness that contrasts with the flat, solid areas of paint seen on the figures. Some parts of the painting look sketchy and unfinished, while others are treated very carefully, as the artist forces our attention to flicker around the different areas and spaces in the room.

Muted earth colors recede into the background

Black provides a perfect foil to intensify the brightness of the orange

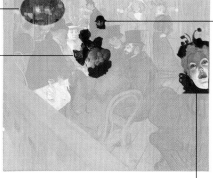

THE ARTIST IN THE PICTURE

Toulouse-Lautrec has included himself next to his cousin, Tapie de Celeyran, whose tall, stooped figure brings an element of caricature to the painting. Lautrec was always very aware of his height and mocks himself by placing his profile against the dark clothes of Celeyran, comically emphasizing both his own lack of stature and Celeyran's height.

A DELICATE FIGURE

The looseness and fluency of this woman, composed of elegant curves and picked out in the most vivid of colors, contrasts with the comparatively heavy and ponderous figures of the men. The men are, after all, paying customers, and the woman, an entertainer known as La Macarona, is at the table for their delight. Compare particularly the dashing paint handling of this head with the reflective and serious execution of the self-portrait.

Chrome orange was the first intense orange pigment to become available to painters

Chrome yellow emphasizes the artificiality of the light

At the Moulin Rouge

HENRI DE TOULOUSE-LAUTREC

1894–95; 48½ x 55½ in (123 x 141 cm)

During the 1890s, the Moulin Rouge was the most famous of the Parisian café-concerts and was visited regularly by Toulouse-Lautrec. Here the extraordinary perspective, with the stage cutting across the left-hand corner, together with the striking color scheme, brings a vivid evocation of the nightlife of Montmartre. The men in the picture are all customers and the women are entertainers, including a famous dancer, La Goulue, who adjusts her hair in the background. Toulouse-Lautrec often concentrated as much on the audience as the performers, with the implication that the dramas offstage are perhaps more significant than those on.

Emerald green, a new pigment made from arsenic, is used in the highlights

ILLUMINATED DANCER

Caught in the sickly glow of the stage lighting, this masklike face is one of the most memorable of Toulouse-Lautrec's characters. She has recently been identified as May Milton, an English dancer who appears in several of the artist's works. The light comes from below and catches her cheeks and eye sockets in a manner that strikingly emphasizes the artificiality of the scene, as she seems to float toward us as if in a trance. Unnatural and evocative moments like this in Toulouse-Lautrec's work sometimes bring him close to the work of the Symbolists (pp. 28–29).

The art of decoration

ENAMEL BROOCH
Two heads are set against a background of stylized animal forms, in a manner derived from the paintings of Gustave Moreau (p. 28).

THE DECORATIVE ARTS have traditionally been given far less importance than the so-called "fine arts" and have generally been thought of as having second-class status. The willingness, therefore, with which both Pierre Bonnard and Edouard Vuillard produced works whose function was primarily decorative indicates that they shared with the Symbolists (pp. 28–29) a contempt for traditional materialistic values. Certain Symbolist echoes can also be seen in the applied arts of the period – the swirling organic shapes and colors, and mysterious, visionary subject matter of painters like Gustave Moreau, Odilon Redon, and Paul Gauguin made themselves visible in jewelry, ceramics, furniture, and poster design. The style became known as Art Nouveau (p. 62).

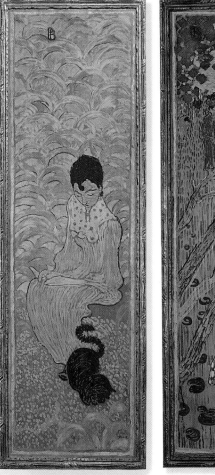

Seated Woman
With a Cat

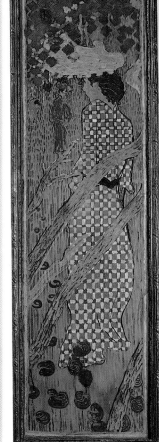

Woman in a
Check Dress

Four decorative panels

PIERRE BONNARD *c.1891; 63 x 19 in (160 x 48 cm)*
The influence of Japanese art, so important for the Impressionists, is still evident here in the way the figures are formed of highly decorative shapes. These four panels were exhibited at the Salon des Indépendants in 1891, giving decorative art a status previously applicable only to "serious" painting. The subject, figures inhabiting a perfect world of harmony and grace, reveals Bonnard's admiration for the work of Puvis de Chavannes (p. 29), and is also related to Symbolist ideas of the artist creating an environment separate from the corruption of the nonartistic world.

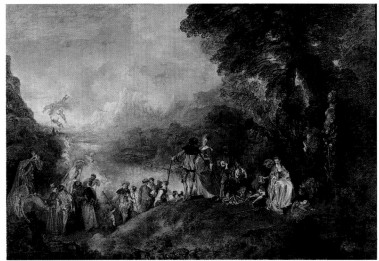

EMBARKATION FOR CYTHERA
Antoine Watteau; 1717; 50¾ x 76¼ in (129 x 194 cm)
Watteau was one of the most celebrated French 18th-century painters, and the world of ideal love and harmony that he created finds strong echoes in the work of Bonnard and Vuillard. Like these artists, Watteau produced paintings for decorative purposes, and this is probably the most important work he made.

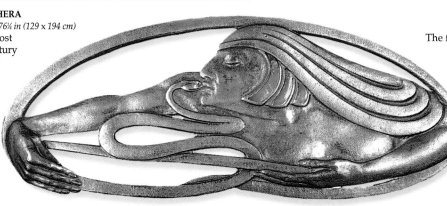

ART NOUVEAU BROOCH
The forms of a figure and a serpent intertwine and kiss, a theme reminiscent of an erotically charged scene from Gustave Flaubert's exotic novel *Salammbo* – a text popular with the Symbolists. The sensuous subject and swirling form of this brooch, designed by Paco Durrio in 1904, combine to create an object that perfectly encapsulates the spirit of Art Nouveau.

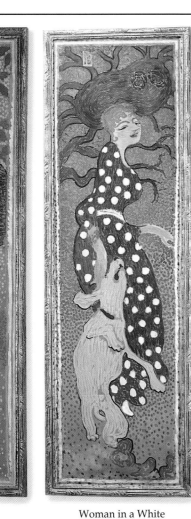

Woman
in a Cape

Woman in a White
Spotted Dress

WALL SHELF UNIT
Emile Gallé; 1890–92; 36½ in (93 cm)
Gallé was a ceramist, glassmaker, and cabinetmaker who worked in Nancy, France, and was one of the main exponents of Art Nouveau (p. 62). Central to the principles of the style was the notion of the unity of the form of the object, as well as its decoration. The flower patterns, the Japanese-style tree forms, and the stylized poppy seed-heads are beautifully crafted and inlaid, uniting to create an organic whole.

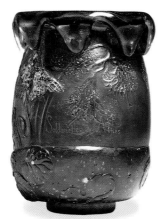

AN ELABORATE VASE
This exquisite vase by Emile Gallé is inscribed with *"Soldanelle des Alpes,"* the Alpine flower patterned on its side. Made from crystal and amethyst, it stands only 4½ in (11 cm) high.

AT THE NEW CIRCUS
*Henri de Toulouse-Lautrec; 1895; 47¼ x 33½ in
(120 x 85 cm); stained glass panel*
This stained glass panel was commissioned by the art dealer Rudolph Bing and made in New York. Bing's Paris establishment was a showpiece of Art Nouveau artifacts; Lautrec's panel was installed over the entrance.

STREET SCENE
*Pierre Bonnard; 1897; each panel:
56¼ x 18 in (143 x 46 cm); colored lithographs*
The format of a screen constitutes the most complete example of the influence of Japan on Bonnard's work. Figures are reduced to the flattest and most decorative of shapes, a "modern life" Parisian subject rendered timeless by its incorporation into the world of artistic decoration. Despite the simplicity of the shapes, Bonnard is still able to suggest space and movement. The screen was printed lithographically in an edition of 110 and designed to be completely freestanding.

Musical Whistler

An American living in London, but spending much of his time in Paris, James Abbott McNeill Whistler (1834–1903) exemplified the ideal of "art for art's sake." This key phrase epitomized the values of the aesthetic movement (p. 62) with which Whistler sympathized – for him it was not so much *what* he painted that mattered, but *how* he painted. Renowned as a great wit, his arrogance won him few admirers, particularly in England, where the tradition of French modernism in which he worked often met with indifference or outright hostility. He liked to use musical terminology when talking of his painting, insisting that line, form, and color were analogous to the keys of a piano. He said that the painter must use these tools "as the musician gathers his notes, and forms his chords, until he brings forth from chaos glorious harmony."

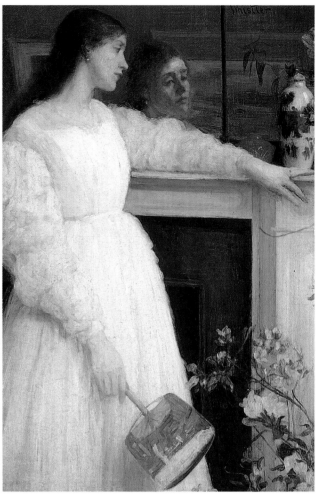

COAST OF BRITTANY
J.A.M. Whistler; 1861;
34¼ x 45½ in (88 x 116 cm)
Whistler left the United States in 1855, aged 21, and initially settled in Paris. He quickly assimilated the Realist style then dominating the French avant-garde, and it is interesting to note that his choice of a Breton subject anticipates Gauguin (pp. 22–23) and Bernard by more than 20 years.

THE LITTLE WHITE GIRL: SYMPHONY IN WHITE, NO.2
J.A.M. Whistler; 1864; 30 x 20 in (76.5 x 51.1 cm)
Painted in England, the dreamy, faraway look of this painting is evidence of Whistler being influenced by the English Pre-Raphaelites. The inclusion of the Oriental porcelain and fan, however, shows that Whistler, like so many of his French contemporaries, was deeply attracted to the art of Japan. The limitation of the color scheme was to become a hallmark of the artist, who added the musical part of the title later, in 1892. The model, Jo Hiffernan, was an Irish woman who later became Whistler's mistress.

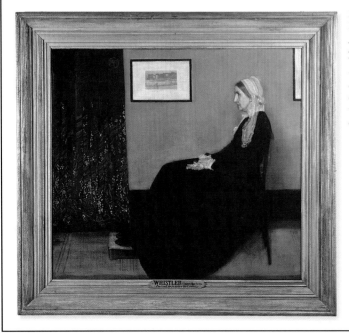

PORTRAIT OF THE PAINTER'S MOTHER
J.A.M. Whistler; 1871;
57 x 64½ in (145 x 164 cm)
The apparent simplicity of this composition was not easily achieved; technical examination has revealed that Whistler made many alterations while working.

ARRANGEMENT IN GREY: PORTRAIT OF THE PAINTER
J.A.M. Whistler; c.1872;
29½ x 20¾ in (75 x 53 cm)
Whistler reacted angrily to criticism that he used more colors in his "arrangements" or "symphonies" than he specified in the title. "Good God, did this ass ... in his astounding wisdom believe that a Symphony in F contains no other note but a continued repetition of F F F Fool?"

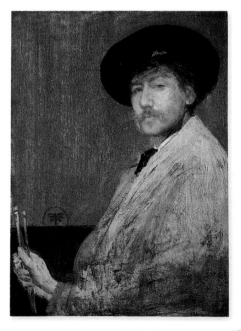

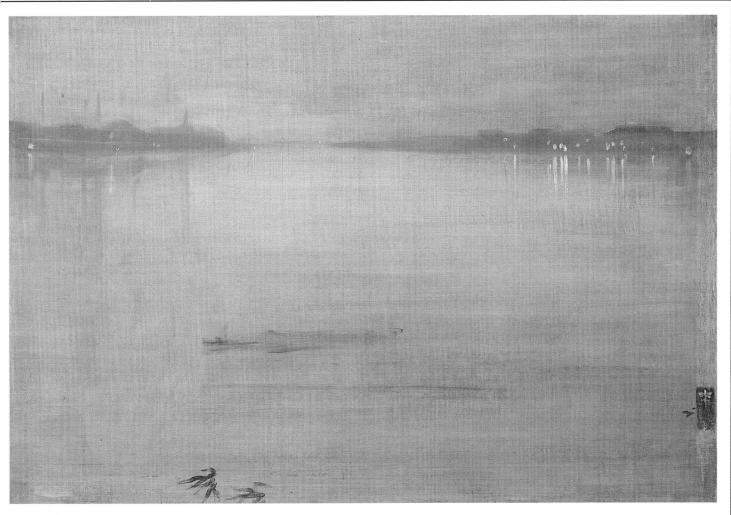

NOCTURNE IN BLUE AND SILVER: CREMORNE LIGHTS

J.A.M. Whistler; 1872; 19¾ x 29¼ in (50.2 x 74.3 cm)
Using the profoundly uninspiring subject of an industrialized area of the river Thames in London, Whistler has created one of his most "musical" compositions. The small flurry of brushmarks at the front is a homage to Japanese calligraphy, as is the way that Whistler signed his paintings – with his "butterfly," seen on the right.

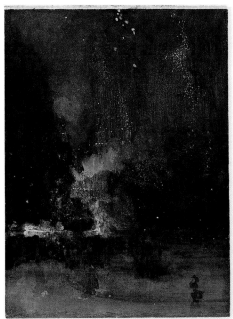

NOCTURNE IN BLACK AND GOLD: THE FALLING ROCKET

J.A.M. Whistler; c.1875; 23½ x 18½ in (60 x 47 cm); oil on oak panel
The near-abstract qualities of this painting were abhorred by the English art critic John Ruskin, who accused Whistler of "flinging a pot of paint in the public's face." Whistler sued Ruskin, but despite winning the case, was awarded only a farthing's damages. The affair bankrupted him.

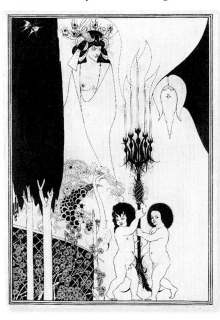

OSCAR WILDE

The great Irish playwright and poet was one of J.A.M. Whistler's closest friends, although the two exhibited an extreme rivalry in public.

YELLOW BOOK

The risqué content of the Yellow Book, which included contributions from Beardsley and Wilde, captured the decadent mood of the time.

THE EYES OF HEROD

The Art Nouveau (p. 62) designs of Aubrey Beardsley provide a perfect characterization of the so-called *"fin de siècle decadence."* When Beardsley first approached Whistler, he was snubbed, but the American was later to acknowledge his talent. This illustration, executed in pen, brush, and ink in 1893, was for Oscar Wilde's novel *Salome*, and includes a harsh caricature of Wilde at the top right.

The new Renoir

PIERRE-AUGUSTE RENOIR (1841–1919) was one of the key figures of Impressionism, and therefore his abandoning of its principles is highly significant. Since the late 1860s, the Impressionist demand for fleeting light effects had dominated Renoir's work, but a trip to Italy in 1881 opened his eyes to the draftsmanship of the great Italian Renaissance painters and led him to question his own achievements. "I had come to the very end of Impressionism," he later wrote, "and came to the realization that I could neither draw nor paint. In a word, I had come to a deadlock." Renoir's way out of this deadlock was to return to the traditional values of classical art, values that the Impressionists, and Renoir himself, had previously rejected as they sought to capture the impermanent.

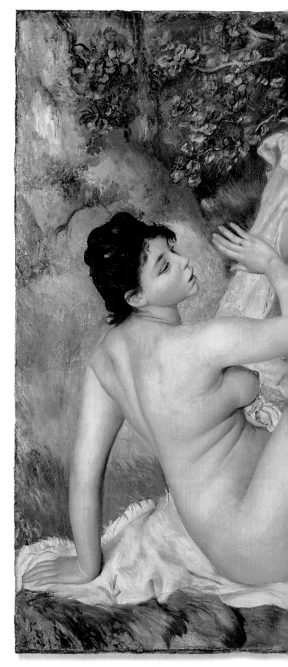

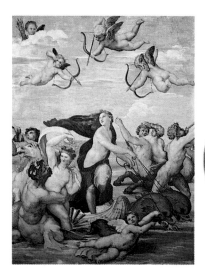

Renoir at home in his wheelchair

TRIUMPH OF GALATEA
Raphael; 1513; fresco
While in Italy Renoir studied this fresco by Raphael, arguably the greatest draftsman of the Renaissance. In this scene from classical mythology, the hard outlines convey a sense of the permanent that convinced Renoir that he was on the wrong path.

TORSO OF A WOMAN IN THE SUNLIGHT (STUDY)
Pierre-Auguste Renoir; 1876; 32 x 25½ in (81 x 65 cm)
This is one of Renoir's earlier and most Impressionist works, which he exhibited at the second Impressionist exhibition of 1876. The animated brushstrokes, with their delicate touches of green and purple, describe the effects of light on the model's skin according to Impressionist ideas of capturing optical truth.

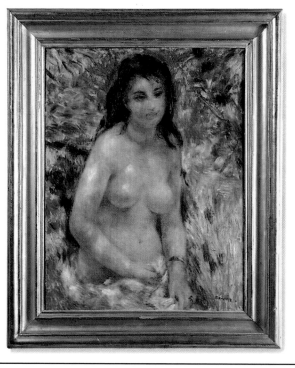

Bathers
PIERRE-AUGUSTE RENOIR
1887; 46¼ x 67¼ in (118 x 170.8 cm)
Even before his trip to Italy, Renoir had been worried about the relatively lightweight and insubstantial qualities of the Impressionists' work. In *Bathers*, he turned to a subject with traditional associations and attempted to make a painting of weight and substance. Fellow artist Suzanne Valadon modeled for Renoir, who began work on the painting in 1884 and finished it in the spring of 1887. Its grand scale makes it anti-Impressionist in intent and, with the nude always a central concern of Renoir, the result is timeless rather than modern, carefully considered rather than spontaneous. In a final rejection of things Impressionist, he painted it in the studio.

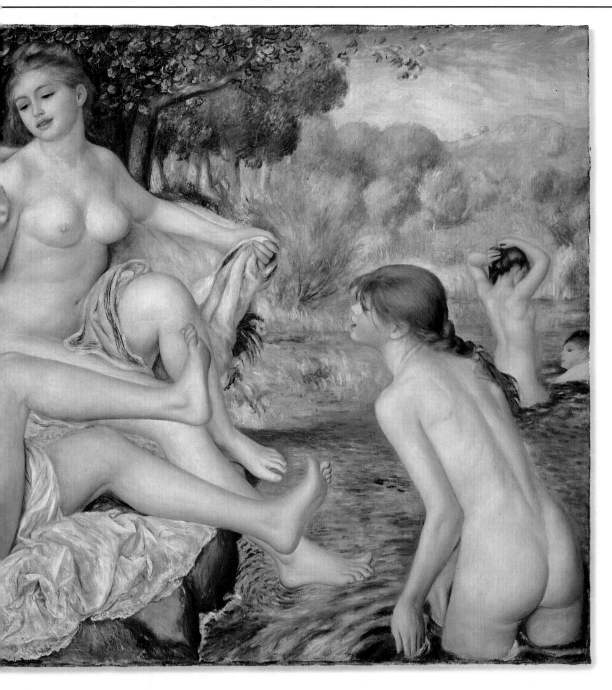

🖌 **CLASSICAL LINEWORK**
The hard line drawn around each of the figures gives them a sculptural quality that is absent from Impressionism. It demonstrates Renoir's new interest in classical draftsmanship, and has a precision that is derived from his careful study of the Old Masters.

🖌 **CEZANNE'S INFLUENCE**
The spontaneous and feathery touch that is typical of Renoir's Impressionist years is replaced here with a smooth and hard finish that seems dry and unyielding – perhaps a result of Renoir's admiration of Cézanne (pp. 46–47).

🖌 **STABILITY**
Cézanne's influence is also detectable in the way that the line does not simply "represent" things but also gives the composition a greater two-dimensional stability.

🖌 **AN IMPRESSED IMPRESSIONIST**
The Impressionist Berthe Morisot visited Renoir's studio while he was making this painting and was struck by the quality of his drawings. "I do not believe that one can go any further in rendering form in a drawing," she said.

BATHERS
Maurice Denis; 1899;
28¾ x 43¼ in (73 x 110 cm)
The subject of the nude bather, with its associations of timelessness and the ideal, proved popular with many other artists of the time. Like Renoir, Denis made a study of Raphael, whose considered classicism contrasted greatly with the "looseness" of Impressionism.

BATHERS (STUDY)
This is one of many studies Renoir made directly from a model, in the studio. During his career as an Impressionist, he had rejected the idea of preliminary studies, but his renewed interest in them shows how anxious he was to reassert traditional values.

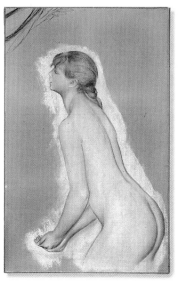

Rural idyll

MANY ARTISTS saw the city in a rather different light to the Impressionists (pp. 20–21) and concentrated on its less attractive aspects. There was also a desire for some sort of antidote to the noisy, impersonal bustle of the boulevards and brothels of the metropolis. Ease of transport, with the rapid expansion of the railroad network, allowed artists such as Camille Pissarro to travel to the country, without being totally isolated from the excitement of the city (which was, after all, where the art dealers were based). It had also become fashionable to seek out so-called "primitive" societies, and the reputation of the Pont-Aven group (pp. 22–23) attracted many artists to Brittany. Even artists outside France began to concentrate more and more on rural subjects where before they had focused on city life.

GIRLS RUNNING, WALBERSWICK PIER
Philip Wilson Steer; 1888–94; 24¾ x 36½ in (62.9 x 92.7 cm)
Steer was an English artist who studied briefly in Paris. Here he shows a "modern life" scene, set in a Suffolk seaside town.

THE APPLE SELLER
Auguste Renoir; c.1890;
26 x 21 in (66 x 53.5 cm)
After his wholesale rejection of Impressionism, marked by the *Bathers* composition of 1887 (pp. 42–43), Renoir again evolved a softer style, often with sentimental subject matter. His view of the countryside was a totally romanticized one. Everything had the feel of hazy contentment, reflecting the artist's own life at the time. Here we see Renoir's young wife, their first child, and their nephew, buying apples – in a world where troubles do not exist.

View from My Window, Eragny

CAMILLE PISSARRO *1888; 25 x 32 in (65 x 81 cm)*
The city was an important part of Pissarro's early career, but in 1884 he settled in Eragny, a small village about two hours from Paris. Suffering from a recurrent eye infection that made it difficult for him to work outside, he made this painting from an upstairs bedroom. He began to adopt a new painting style, with a technique strongly based on Seurat's Neo-Impressionism (pp. 12–17), and felt this method to be superior to the more instinctive "pure" Impressionism that he had been using before.

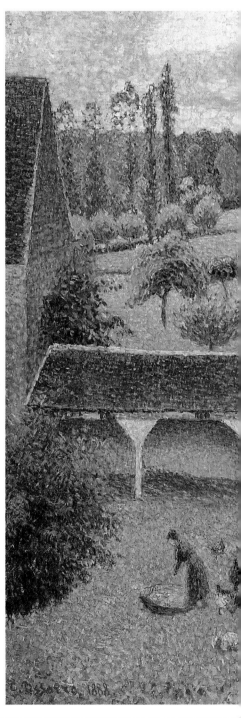

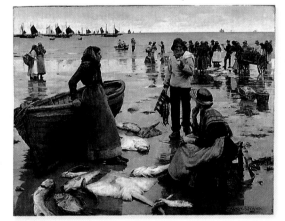

A FISH SALE ON A CORNISH BEACH
Stanhope Forbes; 1885; 48½ x 61¼ in (123.5 x 155.5 cm)
For artists in Great Britain and Ireland, Cornwall provided an equivalent to Brittany. Born in Dublin, Forbes studied briefly in Paris before settling in Newlyn, Cornwall, where he became known for his paintings of Cornish life.

A VIEW OF QUIMPERLE
William Leech; after 1900; 72 x 91 in (183 x 231 cm)
By the time the Irish artist William Leech arrived in Brittany in 1903, "peasant life" had been greatly commercialized. Even so, Leech's paintings, with their contrasting colors that seem both bright and delicate, capture an air of innocence and simplicity.

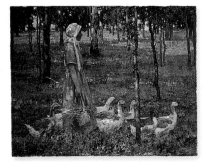

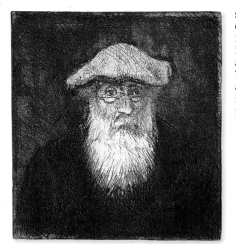

SELF-PORTRAIT
Camille Pissarro; 1890–91;
14¾ x 10¼ in (36 x 26.2 cm); etching
Pissarro shared with Degas (pp. 56–57)
a deep interest in the art of printmaking.
This self-portrait was made on a zinc plate,
and its dark tone and mood of melancholic
introspection are themes also present in the
prints of Rembrandt that Pissarro admired.

FATHER-TO-SON CORRESPONDENCE
Pissarro's letters to his son Lucien are an
invaluable source of information, about
both the artist's ideas on painting, and
his politics. Sympathetic to the ideals of
the anarchist movement, he believed
in individual freedom and the basic
goodness of mankind. Lucien himself
was an influential artist, producing his
best work in England, where he settled.

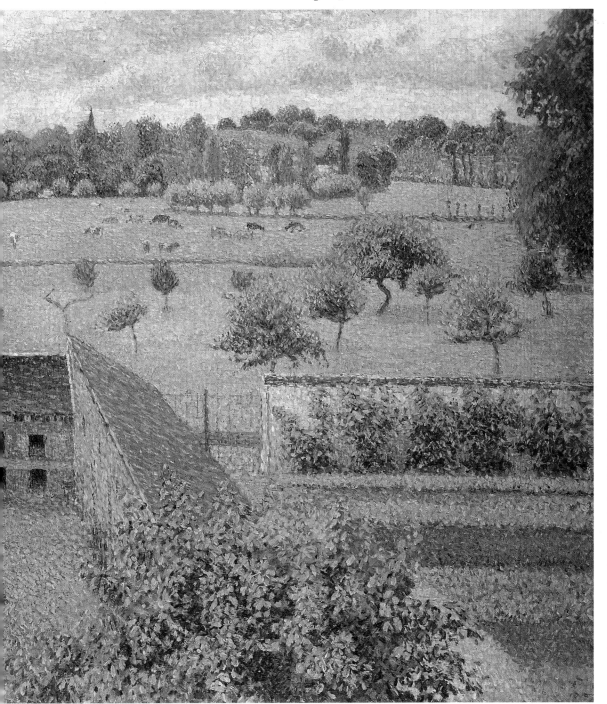

CONTRIVED COMPOSITION
Although made, at
first glance, with the
Impressionist ideal of
direct observation from
nature, this painting has
been carefully contrived,
both in technique and
composition. The notion
of "spontaneity" has
been replaced with
something preplanned.

A RURAL PREFERENCE
Pissarro was deeply
disillusioned with what
he saw as the corruption
of bourgeois city life.
The ordered perfection
of this view of a rustic
agricultural community
reflects his views on the
superiority of traditional
country ways.

PISSARRO'S PROGRESSION
The ordered atmosphere
of this picture is the
result of a carefully
constructed composition,
with strong horizontals
and verticals giving it
great stability. This is in
marked contrast to his
earlier Impressionist
work, which was much
looser and freer.

SEURAT'S INFLUENCE
Emile Bernard wrote
mockingly that Pissarro,
"like every convert,
had become the militant
and dangerous apostle
of that movement
[Neo-Impressionism].
How many painters
committed to that
theory have not the
dignity of his long beard
and of his old talent?"

Cézanne's maturity

AFTER HIS EARLIER Impressionist-style work (pp. 10–11), Cézanne quickly became dissatisfied with the idea of painting about light and external surfaces. His later work shows how he turned away from those principles shown to him by Pissarro and sought to express his visual sensations in a way that conveyed ideas of permanence and solidity. He highlighted the underlying substance of the things depicted – not simply their superficial appearance. He can best be understood as an anti-Impressionist, rejecting the instantaneous as well as the traditional illusionistic methods of representing space. His canvases proudly assert the flatness of the surface, which is kept in a state of high tension with the figures, objects, and landscapes depicted.

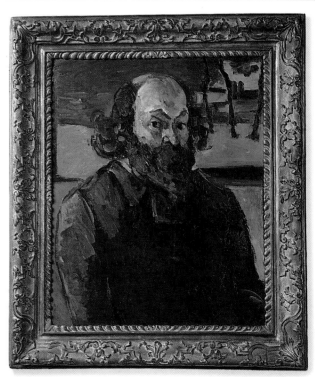

SELF-PORTRAIT
Paul Cézanne; c.1873–76; 25¼ x 20¾ in (64 x 53 cm)
Although sharing something of the romantic quality of his earlier work and the Impressionists' interest in light, the bold pictorial designs of this painting successfully convey three-dimensional stability. All parts of the composition, ranging from the landscape details in the background to the bony structures of the forehead and nose, lock together to bring about a powerful sense of the permanent and unchanging.

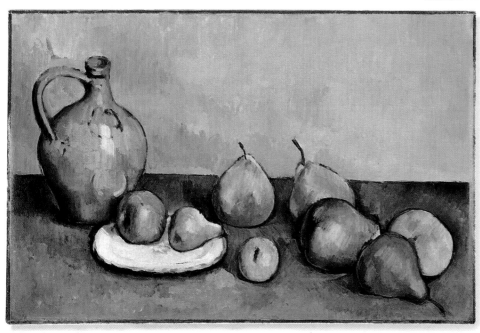

STILL LIFE WITH MILK JUG AND FRUIT
Paul Cézanne; 1885; 17 x 24¾ in (43 x 63 cm)
Cézanne took so long to paint his still lifes that the fruit would shrivel and the flowers would die. This is indicative of his total rejection of the spontaneity of Impressionism; his painstaking technique demanded that he carefully analyze each visual sensation before translating it into paint. He viewed his paintings not as illustrations of his subjects, but as artistic equivalents of them.

DETAIL FROM STILL LIFE
These carefully conceived and executed brushstrokes, with their fine network of parallel hatchings, seem to knit together on the surface – creating a tapestry-like effect of marks that give Cézanne's paintings their tight sense of structure.

PAUL CEZANNE
This photograph was taken in 1904 by Émile Bernard. Cézanne always insisted on painting his landscapes from nature. Ironically, he learned this from the Impressionists, whose work he so dramatically and comprehensively rejected.

A CORNER OF CEZANNE'S STUDIO
These different objects appear in many of Cézanne's later still lifes. He treated only a limited range of subjects in these years, and his range of "props" was similarly small.

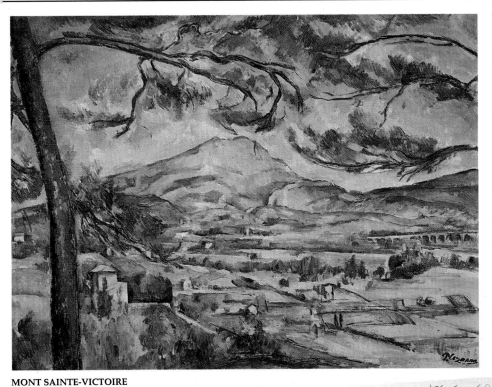

MONT SAINTE-VICTOIRE
Paul Cézanne; c.1887; 26¼ x 36¼ in (66.8 x 92.3 cm)
Cézanne's Mont Sainte-Victoire paintings were often completed only after days, weeks, or months of work – thereby negating Impressionist notions of "spontaneity." Mont Sainte-Victoire, near Cézanne's home, was an ideal subject for him as he sought to express not transient light effects, but the very substance of the mountain itself. Color is not used to represent only the surface of the landscape. It now has an almost symbolic purpose, as Cézanne strives to reveal the massiveness and permanence of nature.

HOMAGE TO CEZANNE
Maurice Denis; 1900; 70¾ x 94½ in (180 x 240 cm)
This work commemorates Cézanne's first one-man exhibition at Ambrose Vollard's gallery in 1895. The Cézanne still life around which the painters – including Redon, Vollard, and the Nabi group (pp. 32-33) – stand was once owned by Gauguin, who also featured it in one of his paintings.

LETTER FROM CEZANNE TO HIS SON
Cézanne's son, also named Paul, did not have a profession of his own, but acted as adviser to his father. Their long correspondence through letters such as this shows how invaluable his support was to Cézanne.

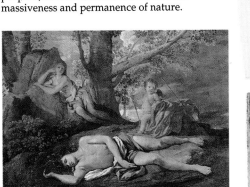

ECHO AND NARCISSUS
Nicolas Poussin; c.1628–30; 29 x 39¼ in (74 x 100 cm)
Cézanne often copied from the Old Masters in the Louvre, and according to his friend Emile Bernard, he once said that his desire was "to do Poussin again, from nature."

THE BATHERS
Paul Cézanne; c.1895; 50 x 77 in (127.2 x 196.1 cm)
Cézanne's later compositions of bathers seem to use the subject as an imaginative way of responding to the past, as he sought to emulate "the art of the museums." The figures and the distant landscape become bound together by Cézanne's use of color. The two groups of bathers, their forms echoed by the arch of the trees, play their role in what is a radical restatement of tradition.

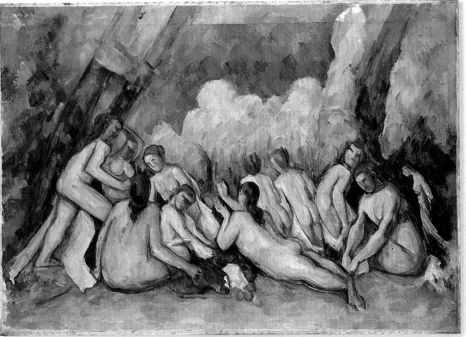

"Le Douanier"

It was not until 1893, when he reached the age of 49, that Henri Rousseau (1844–1910) was able to devote all his time to painting. For the previous 20 or so years he had worked as a minor customs official, painting only in his spare time – hence his nickname, *le Douanier* ("the customs officer"). Nevertheless, he always took himself and his art seriously, and exhibited regularly at the Salon des Indépendants. He was completely untrained, and the "naïveté" of his style was often derided. His extraordinary vision was recognized only by a small group of avant-garde artists and writers, among them the young Pablo Picasso and the poet Guillaume Apollinaire.

MYSELF: LANDSCAPE PORTRAIT
Henri Rousseau; 1890;
56¼ x 43¼ in (143 x 110 cm)
Part of the comic appeal of Rousseau to his contemporaries was his strong belief in his own importance. Palette in hand and wearing a beret, he is proudly declaring himself a modern painter.

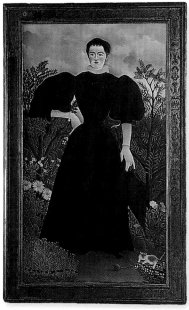

PORTRAIT OF A WOMAN
Henri Rousseau; 1895–97;
78 x 45¼ in (198 x 115 cm)
Rousseau's paintings are always beautifully executed, with a painstaking attention to fine detail, which makes the cat and the plants as fascinating as the actual subject of this portrait – whose identity is unknown.

THE SNAKE CHARMER
Henri Rousseau; 1907;
66½ x 74¾ in (169 x 189.5 cm)
Rousseau's jungle paintings are inhabited by people and creatures that evoke a primitive paradise. He liked to allude to a period of military service in Mexico, but it seems that he never actually left France and produced his jungle paintings from his imagination alone.

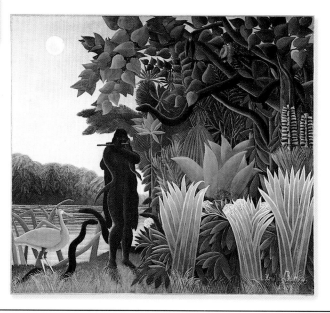

The Sleeping Gypsy
HENRI ROUSSEAU
1897; 51 x 79 in (129.5 x 200.5 cm)
Rousseau was always very serious about the subjects and interpretation of his work. He described this beautiful painting in a letter to a potential client: "A wandering Negress, a mandolin player, lies with her jar beside her (a vase with drinking water), overcome by fatigue in a deep sleep. A lion chances to pass by, picks up her scent, yet does not devour her. There is a moonlight effect, very poetic. The scene is set in a completely arid desert. The gypsy is dressed in Oriental costume."

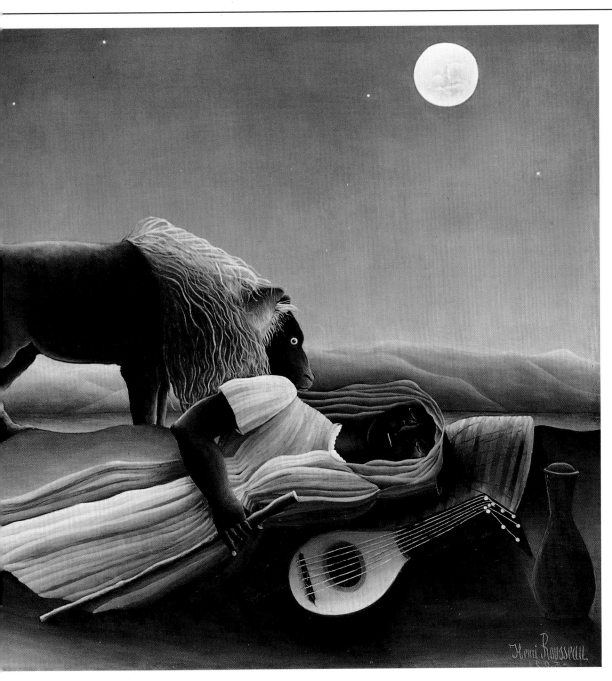

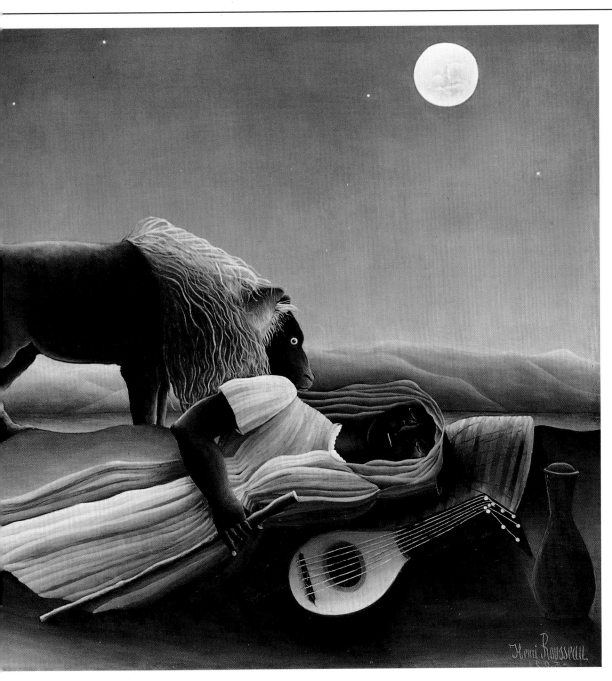

SUBTLE LIGHT
Note particularly the gentle, luminous effect of the night sky and the delicacy of the light as it falls on the back of the lion. Rousseau's ability to convey a moment of an absolute and magical stillness belies his status as a "naive" artist.

DREAMLIKE SCENE
This is one of Rousseau's most haunting, beautiful, and mysterious works. As if seen in a dream, the lion, perhaps symbolizing power and savagery, is stopped in its tracks and tamed by the calm form of the sleeping woman.

THE ARTIST IN ISOLATION
Rousseau's poetic imagination, his sense of the primitive, and the flat, decorative qualities in his work provide points of contact with other artists of the Post-Impressonist generation. However, Rousseau tended to work in isolation and never entered into the same artistic debates as his contemporaries.

ROUSSEAU IN HIS STUDIO
A singer and violinist, Rousseau often gave soirees with guests like Picasso, Braque, Vlaminck, and other figures of early modern art. In 1908, Picasso organized a banquet in his honor, where Rousseau said to him that there were only two great painters alive, "I in the modern manner and you in the Egyptian."

TROPICAL FOREST WITH MONKEYS
Henri Rousseau; 1910;
51 x 64 in (129.5 x 162.6 cm)
The animals in Rousseau's works were often copied from book illustrations, and the lush foliage derived from his visits to the botanical gardens of Paris. The idea of his "naïveté" is challenged by the complexity of compositions such as this.

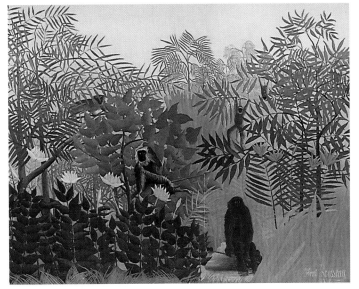

The grotesque

THERE IS NO definable Post-Impressionist style, nor is there a consistency in the subject matter that they were concerned with. One trend, however, that can be detected in a number of the artists who have come to be known as Post-Impressionist, is an attraction to the kind of subject matter that would not, in a previous generation, have been considered suitable for "high art." The ugly and inelegant, the morbid, the strange and unusual, or the frankly grotesque – all had attractions for artists, as the need to find material that was expressive of emotion, mood, and sensations that were not purely visual spread throughout Europe.

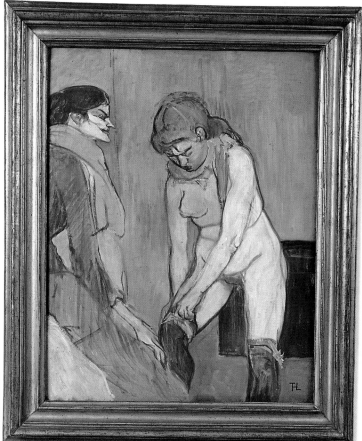

WOMAN PULLING ON HER STOCKINGS
Henri de Toulouse-Lautrec; 1894;
22¾ x 19 in (58 x 48 cm);
oil and pastel on board
This study of a prostitute, watched over by a madame, is one of many works that Lautrec made on the subject of brothels. The ugliness of the figures is strangely offset by the beauty and elegance of Lautrec's line.

THE VOICE
Edvard Munch; 1894; 35½ x 46¾ in (90 x 118.5 cm)
During the 1890s, the Norwegian artist Edvard Munch produced a dramatic series of paintings on the theme of sexual desire. Set in a Nordic pine forest and illuminated by the moon reflected in the lake, *The Voice* is a work of great psychological tension. The woman's hypnotic eyes and seductive stance characterize her as a kind of femme fatale.

SELF-PARODY
Despite his aristocratic background, Toulouse-Lautrec's crippled state (pp. 34–35) led him to mix with the lowest rungs of society – the prostitutes and dancing girls of Montmartre. Always bitterly conscious of his deformed physique, here he is seen parodying himself by dressing up as a samurai warrior.

THE PUNISHMENT OF LUXURY
Giovanni Segantini; 1891; 39 x 68 in (99 x 173 cm)
Segantini became deeply influenced by Divisionism (p.62), a style that made a great impact on the Italian avant-garde. However, the Divisionism of the Italians was freely combined with Symbolist (pp. 28–29) elements that often brought a strange unnaturalness to their work. Here, apparently unconscious female figures float against a naturalistic Alpine landscape in a picture whose "dots" of intensely colored pigment seem to have a life of their own.

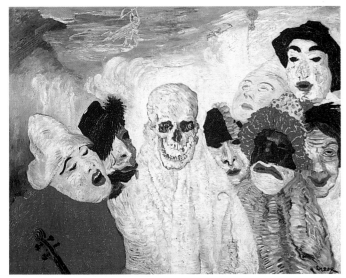

MASKS AND DEATH
James Ensor; 1897; 31 x 39¼ in (79 x 100 cm)
Born in Ostend in 1860, Ensor was a founding member of the Belgian avant-garde group *Les Vingt* ("The Twenty"), a group that had invited van Gogh to exhibit with them shortly before his death. Ensor was a vigorous social critic, and his work was highly expressive, with bright, strident colors appled with great urgency and force. This depiction of a carnival, painted with vivid colors and a swirling brushstroke, carries with it a mood of the sinister and the macabre.

THE PLAGUE
Arnold Böcklin;
1898; 58¼ x 41¼ in (149.5 x 104.5 cm); tempera on canvas
Although the Swiss artist Arnold Böcklin preferred to remain away from developments in France and restrict himself to traveling in Italy and German-speaking countries, he became attracted to the same themes treated by the Symbolist artists (pp. 28–29). Characters drawn from ancient myths populate his paintings, often bringing to his work an atmosphere of disquieting or startling fantasy. Surrealist artists of the 20th century, such as Salvador Dali and Giorgio de Chirico, were influenced by him.

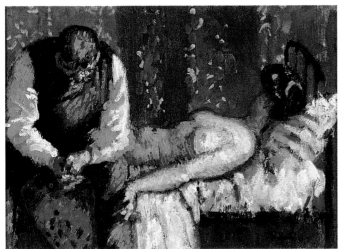

THE CAMDEN TOWN MURDER (OR WHAT SHALL WE DO FOR THE RENT?)
Walter Sickert; 1908; 10 x 14 in (25.6 x 35.5 cm)
The English painter Walter Sickert had been a pupil of James Whistler (pp. 48–49), but rejected his teacher's ideas of aesthetic purity. He took a particularly gruesome murder, which had taken place in an apartment near his studio, as material for a series of paintings. The pictures caused much offense with both the English art establishment and the general public

JUDITH I
Gustave Klimt; 1901; 33 x 16½ in (84 x 42 cm)
The Austrian Gustave Klimt was a leading exponent of *Jugendstil*, the Viennese equivalent of Art Nouveau (p.62), and president of the Vienna Secession – an avant-garde movement founded in 1897. Judith was a Jewish heroine who saved her people by killing the Assyrian general Holofernes and is here presented as a seductive femme fatale. Holofernes's severed head can be seen at the bottom right.

Munch

BORN IN NORWAY, Edvard Munch (1863–1944) studied briefly in Paris, where he was influenced by the Impressionists. Soon after his arrival, he saw an exhibition of Gauguin's work at the Café des Arts. This encouraged him to paint in a manner based on Gauguin's "Synthetism" (p. 63), with large areas of flat color and clear outlines. Munch was an emotionally unstable man, whose subject matter became largely autobiographical as he sought to express his own suffering. "He doesn't need to travel to Tahiti [as Gauguin had done] to see and experience the primitive in human nature," wrote a friend. "He carries his own Tahiti with him."

Edvard Munch photographed in his studio

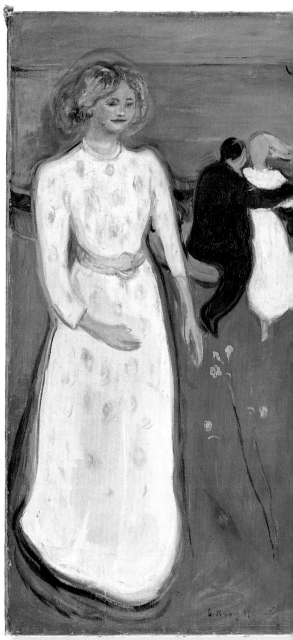

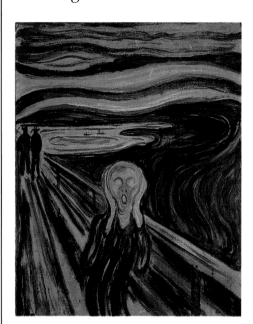

THE SCREAM
Edvard Munch; 1893; 29¼ x 22 in (74 x 56 cm); pastel on board
The skull-like head is Munch, his features distorted to express the terrifying sense of isolation and despair that he suddenly felt one evening. The dramatic perspective made by the bridge, and the swirling lines of the sky and landscape, give this picture a dizzy effect. "I felt a breath of melancholy. Suddenly the sky turned blood red ... I stood there trembling with anxiety and I felt a great, infinite scream pass through nature." Munch considered this statement crucial for a full appreciation of the painting.

EVENING ON KARL JOHAN'S STREET
Edvard Munch; 1893; 33½ x 47½ in (85 x 121 cm)
The sun is setting and its golden rays reflect in the windows. The rushing perspective and masklike faces, with their gaunt, hollow eyes, give this picture a sense of desperate isolation. Despite being together in a crowd, the figures do not communicate, but stare blankly as if hypnotized. On the right, the dark shadow of a tree looms threateningly over a lone figure, identifiable from his diaries as Munch himself.

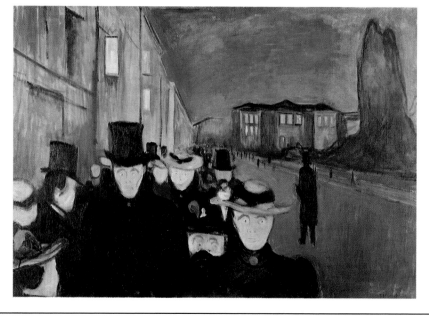

The Dance of Life
EDVARD MUNCH
1899; 49½ x 75 in (125.5 x 190.5 cm)
"We should no longer paint interiors with people reading and women knitting. They should be people who live, breathe, feel, suffer, and love." Munch's statement represents a declaration of his belief that art must go beyond the external appearances of Impressionism and convey instead feelings from within. Here, he uses his own unhappy experiences with women as his subject matter. These experiences affected him deeply and caused him almost constant despair.

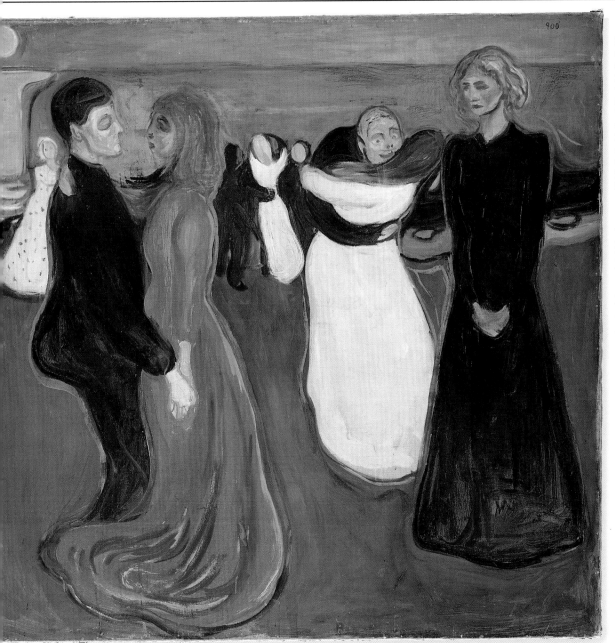

HAUNTING QUALITY
Set outside, under an evening sky, *The Dance of Life* is a symbolic representation of the two principal love affairs of Munch's life. The abstract shapes of the moon and its reflection, and the flat areas of atmospheric color, give this picture a haunting, surreal quality.

MUNCH'S INFATUATION
The central pair are Munch and the woman he was infatuated with, "Mrs. Heiberg" (Munch's pseudonym for her). A married woman, she had ended their affair in the 1880s, leaving Munch feeling abandoned and desolate.

A WOMAN'S ATTENTIONS
On the left, in white, is Tulla Larsen, with whom Munch had a long-term but unhappy relationship. This had also ended by the time Munch painted this picture, illustrating the suffering that he was still going through.

STIFLING LOVE
On the right, this time in black, is Tulla Larsen again, who is herself rejected. Munch found the demands of her love stultifying and oppressive, draining him of his energy to paint.

PUBERTY
Edvard Munch; 1894–95;
59½ x 43¼ in (151.5 x 110 cm)
A naked adolescent girl, attempting to conceal her body with spindly arms, sits starkly lit on the edge of a bed. The looming shadow evokes her fears and anxieties at her awakening sexuality, but also seems to hint at the ever-present threat of death.

DEATH IN THE SICKROOM
Edvard Munch; 1893;
53 x 63 in (134.5 x 160 cm)
A memory of the childhood death of Munch's younger sister Sophie, this painting is one of many that he painted on the theme of death. The artist and his two surviving sisters are in the foreground; in the background, the dead child is hidden by a chair.

Rodin's sculpture

AUGUSTE RODIN (1840–1917) is one of the key figures in the history of Western sculpture. He produced work that, with its interest in capturing movement, can be related to the Impressionists, but equally he produced much that was deeply anti-naturalistic – firmly rejecting the idea that the art of sculpture should be purely imitative. His struggle to use the human body to express sensations of emotion, suffering, or spiritual anguish characterizes him as one of the great Romantics (p. 62) of this period. In addition to his sculpture, Rodin left nearly 8,000 drawings. These were a vital means of expression to him – not made simply as studies, but as ends in themselves. Although much of his work was highly controversial, many of Rodin's figures have today become accepted as landmarks in the history of art, notably his great Balzac monument, which is widely recognized as the first truly "modern" sculpture.

PHOTO OF RODIN
Rodin's history was one of turbulence and drama – both in his public and private life. He has since been seen as the archetype of the Bohemian artist, suffering for his art.

DRAWING OF CENTAUR
This brooding image, executed with dark and heavy penwork, shows a centaur carrying off a woman. There is little doubt that Rodin identified with the centaur – one of the classic themes of Romantic art and traditionally symbolic of the instinctive, as opposed to the rational side of man's nature.

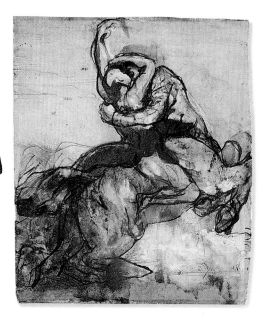

THE THINKER
Auguste Rodin; 1880–81; 27 in (68.5 cm); bronze
Rodin was commissioned by the state to make, in bronze, a piece entitled *The Gates of Hell*, as doors to the Museum of Decorative Arts in Paris. The project was never completed, but Rodin enlarged many of the figures conceived for the gates, and they became finished works in their own right. *The Thinker* started as a representation of Dante, whose "Inferno" provided Rodin's inspiration.

EVE
Auguste Rodin; 1881; 76¼ x 35½ x 23½ in (195 x 90 x 60 cm); bronze
Also originally destined for *The Gates of Hell*, Rodin's *Eve* is considerably over life-size. She conceals her face with her arms, forming herself into a pose that dramatically conveys her overwhelming sense of shame. Rodin's technical strengths were as a modeler rather than a carver, and *Eve* was initially modeled in plaster and then cast in bronze, a process that preserved the beauty of Rodin's surfaces.

Rodin would often instruct his models to move around the studio freely and not to adopt a static pose. Then, without taking his eyes away from the model, he would make rapid and spontaneous pencil sketches, such as this one, in an attempt to capture her movements. By using this radical method, Rodin hoped to co-ordinate his visual sensations with the gestures made by his hand, in a manner that was instinctive rather than predetermined. When the drawing was completed, the artist would lightly tint it with a wash of watercolor.

CAMILLE CLAUDEL
Rodin's relationship with Claudel was just one of his many turbulent love affairs.

THE AGE OF MATURITY
Camille Claudel; c.1895; 45 x 64¼ x 28¼ in (114 x 163 x 72 cm); bronze
The sculptress Camille Claudel portrays herself on her knees, in a work influenced by her lover, Rodin. Rodin himself is shown lured away by a winged old woman, a symbolic representation of his long-term mistress Rose Beuret.

MONUMENT TO BALZAC
Auguste Rodin; 1897–98;
106 x 48¼ x 41 in (269.2 x 123.2 x 104.1 cm); bronze
Rodin won the commission to commemorate the great French writer Honoré de Balzac, who died in 1850, but the result caused such anger that the piece was rejected. The squat, simplified bulk dramatically announces the intellectual power of Balzac, whose statement, "the mission of art is not to copy nature, but to express it," seems perfectly evoked. Rodin made many models for this piece, as he sought to discover the most powerfully expressive form to symbolize (rather than represent) the writer, whose ideas were deeply influential on the Post-Impressionist generation.

Degas – tradition restated

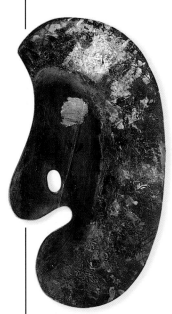

Degas' palette

ALTHOUGH HE WAS one of the central figures of Impressionism, Edgar Degas (1834–1917) had always shown a deep interest in the traditional practice of drawing from the figure – in direct contrast to the other Impressionists. His art was firmly studio-based, and he once said that painters should be kept indoors by a special police force, "with a little whiff of grapeshot to stop them from painting landscapes from nature." He also experimented with both sculpture and printmaking, mediums that are incompatible with the making of spontaneous, "Impressionist" images. His later work became increasingly artificial, his models "acting out" drying their hair or bathing, and he often made use of the camera as an aid to his compositions.

DEGAS IN HIS STUDIO
The word "Impressionist" is slightly misleading when applied to Degas, here pictured in 1898. He had joined the group long before the term was invented, and in a revealing statement said, "No art was ever less spontaneous than mine."

THE REHEARSAL
Edgar Degas; 1877; 23 x 33 in (58.4 x 83.8 cm)
The ballet was an ideal "modern life" subject for Degas, whose countless nudes are testimony to his fascination for the female body. He was also interested in exploring alternative ways of portraying what he saw before him. In this painting, shown at the fourth Impressionist exhibition of 1879, the different poses of the dancers and their translucent costumes allow Degas to explore a variety of different light effects.

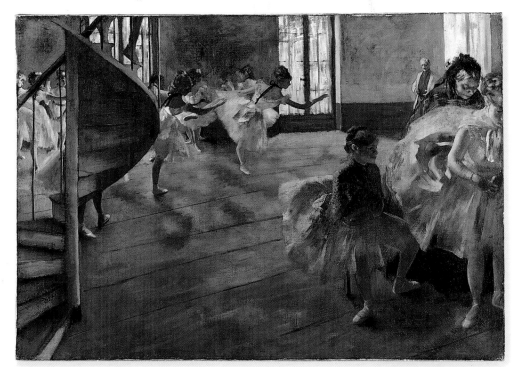

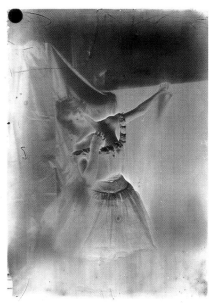

DEGAS SNAPSHOT
Degas was attracted to the medium of photography because of the possibility of "freezing" a pose, as he has done here. He was not interested in rendering the fleeting or impermanent, and photography allowed him to make a careful study of fixed poses.

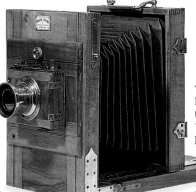

A NEW ART FORM
Photography was still a relatively crude affair when Degas acquired his camera in the late 1880s; it would have been not unlike this one (left). The photograph shown here (right) is one of the readily available "pornographic" photographs that Degas may have used as source material for his paintings.

JAPANESE INFLUENCE
In traditional Western art, the female nude is usually presented as an ideal of grace and beauty. In the Japanese illustrator Katushika Hokusai, Degas discovered an artist whose bathhouse studies (left) in *La Manga* (1817) showed the nude in various expressive poses that inspired his own art.

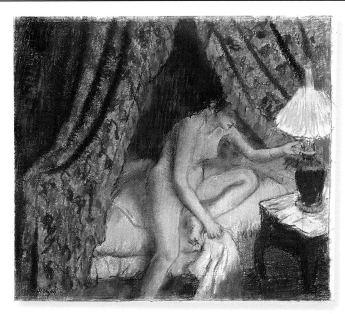

RETIRING
*Edgar Degas; c.1883;
14¼ x 17 in (36.4 x 43 cm); pastel*
Pastel was a medium Degas enjoyed; it allowed him to make quick alterations while modeling the forms. Degas' controlled draftsmanship, with the hard line defining the pose, is a consistent feature of his work.

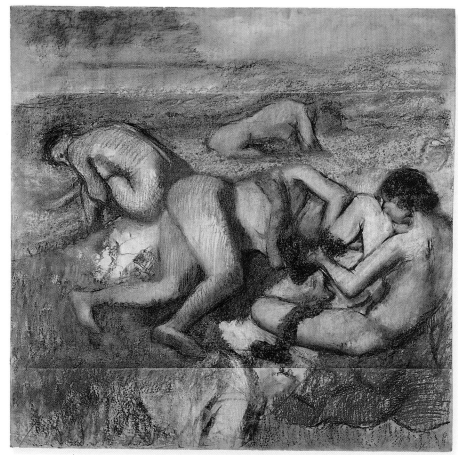

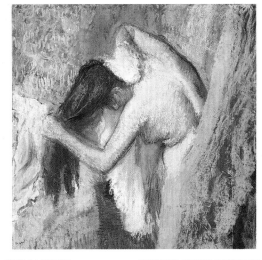

THE BATHERS
*Edgar Degas;
c.1898–1905; 41¾ x 43 in
(106 x 109 cm); pastel*
The outdoor setting of this pastel is totally artificial, and bears a resemblance to Gauguin's mysterious *Day of the God* (pp. 30–31), which Degas owned at this time.

WOMAN AT HER TOILETTE
*Edgar Degas; c.1900–1905;
29½ x 28½ in (75 x 72.5 cm); pastel*
Degas became obsessed with the idea of women bathing. This voyeuristic image seems natural, but is in reality contrived.

REPOS
This monotype – a form of printing where ink is painted onto a metal plate and a print taken from it – was made by Degas in 1879. He became fascinated with the medium, using it to depict numerous brothel scenes. Picasso greatly admired Degas' monotypes and gathered a large collection of them.

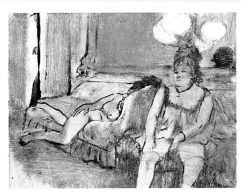

WOMAN DRYING HER LEFT HIP
*Edgar Degas; c.1896–1911; 14 x 9¾ x
15¼ in (35.4 x 25 x 38.5 cm); bronze*
As he got older, Degas began to suffer problems with his eyesight, and he turned increasingly toward sculpture, a medium that allowed him to employ touch as well as sight. The figures were initially modeled in wax before they were finally cast in bronze.

Late Monet

Cᴌᴀᴜᴅᴇ Mᴏɴᴇᴛ (1840–1926) is often seen as the most typical of the Impressionists, yet his later works challenge this assumption. He refused to show at any of the last four Impressionist exhibitions, demonstrating that already by 1880 his ideas were developing beyond the simple need to capture external light effects. His move to Giverny in 1883, where he created his famous water garden and built a large studio, provided him with a ready-made subject that preoccupied him for the rest of his life. By 1890, his reputation was international and his status secure, allowing him to experiment with color and scale in an unprecedented way.

MONET IN HIS WATER GARDEN
From 1903, Monet suffered increasingly from cataracts. An operation in 1923 restored some of his vision, but many of the canvases that he produced during this time are principally the result of memory and determination. In contrast to the optical experience so important for a "pure" Impressionist painting, he remarked, "I have rediscovered the powers of intuition and allowed them to dominate."

Setting Sun

CLAUDE MONET
1914–18; 77½ x 236¼ in (196.8 x 600 cm)
The size and time scale of this picture is a direct challenge to Impressionist ideas of spontaneity. This composition was painted in the Orangerie (right), and its emphatic exclusion of the horizon and its fusion of things reflected in the water combine with a sense of an all-pervasive atmosphere to establish a brilliant tension between three-dimensional illusionism and the flatness of the painted surface.

THE ORANGERIE, PARIS
Monet painted a series of canvases for installation in the Orangerie. These paintings are a remarkable testament to the genius of the partly blind octogenarian who made them.

SETTING SUN DETAIL
Monet painted many pictures of the same view, but often under radically different atmospheric conditions. These works seem to hover on the boundary between an Impressionist-style "representation" and a purely intuitive and expressive response.

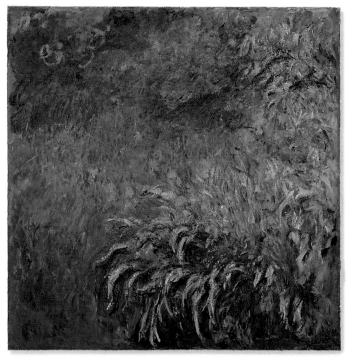

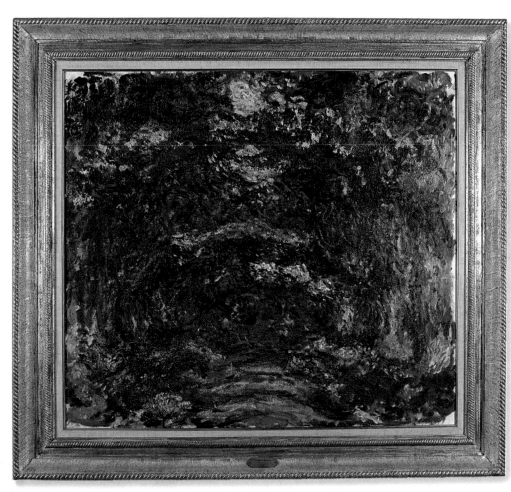

MONET'S SKETCHBOOK
Monet's sketchbooks of this period contain loosely drawn indications of trees, plants, and other features of his garden. They often seem to have a classical structure that provided him with a compositional starting point for his large-scale paintings.

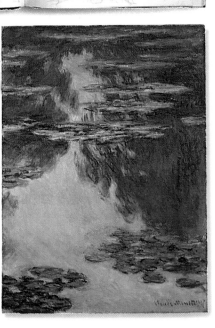

WATERLILY POND
Claude Monet; 1907;
40 x 29¼ in (101.5 x 74.5 cm)
The swirling rhythms of the reflections and the delicate tones have an abstract quality to them that is consciously musical. Monet wanted his paintings to "succeed in touching us, as a musical phrase or chord touches us, in the depths of our being, without the aid of a more precise or enunciated idea."

IRISES AT THE SIDE OF THE POOL
Claude Monet; c.1919; 79 x 78¾ in (200.5 x 200 cm)
Monet's paintings of irises, with their vigorous and dragged-on handling of paint, are not so much literal depictions of a particular scene, but vivid expressions of life – both of the springtime that brought forth these plants, and of Monet's own life. Paintings like this were an inspiration for many 20th-century artists, particularly the Americans known as the Abstract Expressionists, for whom Monet is often seen as a predecessor.

PATH WITH ROSE TRELLISES AT GIVERNEY
Claude Monet; 1920–22; 32 x 39¼ in (81 x 100 cm)
Even when his cataracts were at their worst, Monet refused to allow a mere physical disability to prevent him from painting. Combining memory and imagination with the hazy, indistinct visual sensations that remained, he turned his handicap into a positive advantage. Rooted in his experiences as an Impressionist, when his wish was to capture the external light effects, this painting expresses Monet's sense of wonder and exuberance at the works of nature.

ROSE TRELLISES DETAIL
This detail shows Monet's technique of working and reworking the surface of the picture, with rapidly applied marks that are instinctive, almost abstract, gestures.

New beginnings

THE TERM "POST-IMPRESSIONISM" has come to embrace the early work of the two most significant artists of the 20th century, Pablo Picasso and Henri Matisse. Furthermore, their later work, even at its most revolutionary, is ultimately rooted in the period covered by this book. The value of the Post-Impressionist artists is not simply confined to their actual work, nor even to their great influence, but includes the tremendous freedom that they won for the next generation of artists. They were now no longer bound by the old convention that limited artists to an external representation of things, a convention that had ruled art for almost five centuries.

PABLO PICASSO
This photograph shows Picasso aged 23, at about the time he settled permanently in Paris. He was drawn there by the reputation of Paris as a city with a recent tradition of being a home to the great revolutionary artists of the 19th century. Picasso's career was launched by his study of the Post-Impressionist painters.

FRUIT BOWL WITH PEARS AND APPLES
Pablo Picasso; 1908; 10¾ x 8¼ in (27 x 21 cm); oil on wood panel
This still life, from Picasso's early Cubist period, is concerned both with representing the solidity of the objects depicted and emphasizing the flatness of the picture surface. At this time, both Picasso and Georges Braque wanted to stress the fact that the picture is an object in its own right and not simply an illusion. The two artists made a serious study of Cézanne's achievements (pp. 46–47) and were profoundly influenced by him.

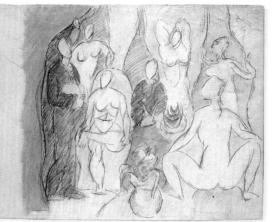

LES DEMOISELLES D'AVIGNON (STUDY)
Pablo Picasso; 1907; 18½ x 24½ in (47 x 62.5 cm)
This study depicts a young man in a brothel, and shows Picasso sharing the concerns of many of the Post-Impressionists. There are similarities with Cézanne's *Bathers* (opposite), particularly in the female on the right.

GEORGES BRAQUE IN HIS STUDIO
Picasso and Braque together invented the style of painting known as Cubism (p. 62). Crucial to its development was an understanding of Cézanne and a deep fascination with the art of so-called "primitive" cultures, already anticipated in the work of Gauguin (pp. 30–31). Here, Braque is shown with some of the tribal artifacts in his collection.

PAYSAGE
Georges Braque; 1908; 32 x 25½ in (81 x 65 cm)
Like Picasso, Braque was a great admirer of Cézanne. Emulating his artistic hero, he made a series of Cubist landscapes at l'Estaque, the scene of some of Cézanne's finest work. The simplified forms of the trees and the buildings, becoming almost geometrical shapes, give the painting the same kind of structure that was so important to Cézanne.

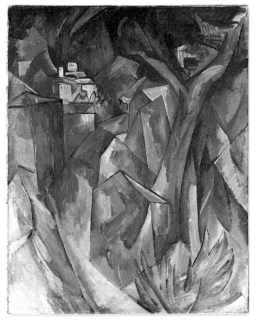

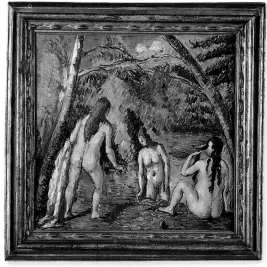

BATHERS
Paul Cézanne; c.1879–82; 20½ x 21¾ in (52 x 55 cm)
Although he could hardly afford it, the 26-year-old
Matisse bought this small painting at Cézanne's first
one-man exhibition (p. 47). The way that Cézanne
created form and space through his manipulation of
color, and the rigid pictorial structure of this painting,
taught Matisse important lessons during a
vital period in his development as an artist.

LUXURY, CALM, AND DELIGHT
Henri Matisse; 1904; 38½ x 46½ in (98 x 118 cm)
Matisse was the leader of a group of artists who, together
with the Cubists, made the most significant advances in
early 20th-century painting. Known as Fauves, or "wild
beasts," because of their use of expressive color, and
influenced by van Gogh and Gauguin, they also drew on the
subject matter of the Symbolists and the technique of Seurat.

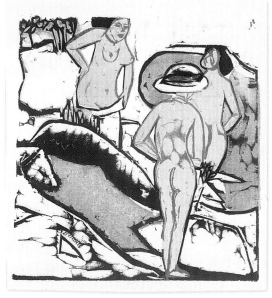

GERMANIC ART
This print, *Women Bathing Between Stones*, is by Ernst
Ludwig Kirchner, a member of a German group known as
Die Brücke ("the Bridge"). He aimed to create a uniquely
Germanic art, although its origins were in the "primitivism"
of Gauguin (pp. 30–31) and the "expressionism" of van Gogh.

STANDING NUDE
Henri Matisse; 1899; 25¼ x 19¾ in (65.5 x 50 cm)
Powerful colors, broken up on the picture surface,
derive from Seurat's Neo-Impressionism (pp. 12–17) and the
expressive color of van Gogh. The composition locks together
in a manner learned from Cézanne, showing how important
the Post-Impressionists were to Matisse's early work.

Post-Impressionist movements

Aestheticism Immanuel Kant's 18th-century theory of art that held that the philosophy of art is separate from any other philosophy and should be judged only by its own standards ("art for art's sake"). Whistler was closely associated with Aestheticism, preferring the suggestive and evocative to the specific or didactic.

Art Nouveau The decorative "New Art" of the 1890s that used naturalistic, organic forms. It embraced architecture and design, as well as painting.

Cloisonnism A style of art pioneered by Emile Bernard and Louis Anquetin in which flat colors were separated by strong blue or black outlines in the manner of Cloisonné enamel decoration.

Cubism A style of painting and collage developed by Picasso and Braque in early-20th-century Paris, and the first great art movement of the century. Based partly on the work of Cézanne, Cubism rejected the traditional single viewpoint in favor of more experimental work.

Decadence 19th-century artistic and literary movement associated with Symbolism. Characterized by a taste for the perverse and a belief in the superiority of the artificial to the natural.

Divisionism The color theory and technique developed by Neo-Impressionists Seurat and Signac, based on color theories by scientists such as Chevreul, whereby paint was applied in dots of pure color. Also known as Pointillism.

Expressionism Art in which forms arise not directly from observed reality but from subjective reactions to reality. The term was popularized by German art critic Herwarth Walden, publisher of the avant-garde review "*Der Sturm*," to embrace all modern art opposed to Impressionism.

Fauvism The name *Les Fauves* (The Wild Beasts) was applied by a hostile critic to artists such as Matisse, who exhibited at the Salon d'Automne in Paris in 1905. Characteristics of Fauvism are brilliant color, abstract shapes, and distortions of figurative forms. The group disbanded in about 1908.

The Nabis The Hebrew word for prophet, "Nabis" was the name adopted in 1889 by a group of French painters influenced by the work of Paul Gauguin. Maurice Denis, Pierre Bonnard, and Edouard Vuillard abandoned their academic training to use brilliant colors that denied traditional perspective. The Nabis were committed to the applied arts, and produced stained glass, ceramics, and book illustrations in addition to easel paintings.

Skiff at Sunset, Odilon Redon

Neo-Impressionism see Divisionism

Pointillism see Divisionism

Primitivism Applied disparagingly in the 19th century to northern European and Italian painting pre-dating the 16th century, the term was also used to describe non-European art that did not conform to the Western ideals of linear perspective and realism. It later came to describe artists such as Gauguin, who adopted non-Western aesthetics, and the "naïve" style of Rousseau.

Surrealism A movement originated in the 1920s, when André Breton created a philosophy for a group of artists and writers. Their objective was "pure psychic automatism" – an exploration of the irrational and subconscious. Surrealists included Miro, Magritte, and Dali.

Symbolism A late 19th-century French literary movement that influenced the visual arts. Symbolist painters such as Redon, Moreau, and Klimt sought to convey ideas and suggest emotions rather than imitate the external forms of nature.

Synthetism Used to describe the work of Gauguin and the Pont-Aven group. Its characteristic feature was the combining of color and shape to provide pictorial equivalents, rather than imitations, of the things depicted.

Key featured artists

Anquetin, Louis (1861–1932) Began as an Impressionist, before evolving Cloisonnism with Bernard.

Bernard, Emile (1868–1941) An admirer of Gauguin, he experimented with various styles, including Cloisonnism, before falling under the influence of the Nabis.

Bonnard, Pierre (1867–1947) As a Nabi artist he was involved in the applied arts. Later switched to a more Impressionist style.

Cézanne, Paul (1839–1906) Associated with Impressionism, but grew more committed to form and structure rather than to the superficial appearance.

Degas, Edgar (1834–1917) An Impressionist increasingly influenced by photography. Prolific in his study of dancers and contemporary subjects, he was one of the great innovators of his age.

Denis, Maurice (1870–1943) A founding member of the Nabis, he was highly significant as a theorist.

Gauguin, Paul (1848–1903) He evolved a style that liberated color from its representational function. One of the most important figures in the evolution of 20th-century art.

Gogh, Vincent van (1853–90) Experimented with Impressionism and Pointillism before developing a style of strong, rhythmic forms and heavy impasto work.

Matisse, Henri (1869–1954) Influenced by Impressionism and Post-Impressionism, before adopting luminous color and a concern for structure. Helped create Fauvism.

Monet, Claude (1840–1926) Leading Impressionist, dedicated to the visual sensation and to painting directly from the object.

Moreau, Gustave (1826–98) Key Symbolist and teacher to the Fauves, his style was richly ornate and exotic.

Munch, Edvard (1863–1944) Influenced by Impressionism, Gauguin, and van Gogh. He represents the link between Post-Impressionism and Expressionism.

Picasso, Pablo (1881–1973) Influenced by a number of Post-Impressionists, and he was one of the originators of Cubism. One of the most influential artists of the 20th century, he had a profound effect on the development of art.

Pissarro, Camille (1830–1903) A founding Impressionist, he briefly acquired a Pointillist technique and influenced many Post-Impressionists.

Puvis de Chavannes, Pierre (1824–98) A student of Delacroix and Couture, he favored mythological and symbolic subjects in his murals and decorative work.

Ranson, Paul (1862–1909) Master of many art forms. He discussed aesthetics and philosophy with fellow Nabis.

Redon, Odilon (1840–1916) Untouched by Impressionism, he devoted 20 years to drawings and lithography, later using color in an uninhibited and explosive way.

Renoir, Pierre-Auguste (1841–1919) He was originally influenced by Courbet, but as an Impressionist was devoted to painting outdoors. Later adopted a more elaborate technique.

Rodin, August (1840–1917) The most successful experimental sculptor of his time. Interested in literary and symbolic associations, as well as dance.

Rousseau, Henri (1844–1910) Took up painting late, using a "naïve" style that was highly influential.

Sérusier, Paul (1864–1927) Founder member of the Nabis. Began as an academic painter, before being influenced by Gauguin.

Seurat, Georges (1859–91) Influenced by Ingres and Puvis de Chavannes, he developed the color theory of Pointillism.

Signac, Paul (1863–1935) An Impressionist converted by Seurat to Pointillism, he helped found the Salon des Indépendants.

Toulouse-Lautrec, Henri de (1864–1901) Influential Parisian artist who liberated color from its descriptive function in a range of stylized paintings, prints, posters, and drawings.

Vuillard's sketchbook

Vuillard, Edouard (1868–1940) Founding Nabi artist influenced by Gauguin and Japanese art.

Paintings on display

The following is a list of the galleries and museums exhibiting the paintings by Post-Impressionists that are reproduced in this book.

*Key: t = top b = bottom c = center
l = left r = right*

p. 6 tr: *The White Horse*, Gauguin, Musée d'Orsay, Paris; bl: *Bathers at Asnières*, Seurat, National Gallery, London; br: *Bedroom at Arles*, van Gogh, Art Institute of Chicago (AIC).

p. 7 tl: *The Chat*, Vuillard, Scottish National Gallery of Modern Art; tr: *Flowers in a Vase*, Redon, AIC; c: *La Macarona*, Toulouse-Lautrec; *The Equatorial Jungle*, Rousseau, National Gallery of Art, Washington; br: *La Montagne St. Victoire*, Cézanne, Kunstmuseum, Basel.

p. 8 cl: *The Tub*, Degas, Glasgow Museums and Art Galleries; b: *La Roche Guyan*, Renoir, Aberdeen Art Gallery.

pp. 8–9 *A Sunday on La Grande Jatte*, Seurat, AIC.

p. 9 bl: *Dawn of the Last Day*, Redon, AIC; cr: *Girl Arranging Her Hair*, Cassatt, National Gallery of Art, Washington; br: *Women Bathing*, Gauguin, National Museum of Western Art, Tokyo.

p. 10 tl: *Portrait of Louis-August Cézanne, The Artist's Father*, Cézanne, National Gallery of Art, Washington; cl: *Pastoral (Idyll)*, Cézanne, Musée d'Orsay, Paris; br: *Still life: Green Pot and Pewter Jug*, Musée d'Orsay, Paris.

pp. 10–11 *The House of the Suicide*, Cézanne, Musée d'Orsay, Paris.

p. 11 br: *Village of Voisins*, Pissarro, Musée d'Orsay, Paris.

p. 12 cl: *The Valpinçon Bather*, Ingres, Louvre, Paris; bc: *Study for Les Poseuses de Dos: Model from Behind*, Seurat, Musée d'Orsay, Paris.

pp. 12–13 *Les Poseuses*, Seurat, National Gallery, London.

p. 14 *Sunset at Herblay*, Signac, Glasgow Museums and Art Galleries.

p. 15 tl: *Landscape with Willow Trees*, Luce, Glasgow Museums and Art Galleries; c: *The Gleaners*, Pissarro, Kunstmuseum, Basel; bl: *L'Air du Soir*, Cross, Musée d'Orsay, Paris.

p. 16 tr: *Gravelines*, Seurat, Courtauld Institute, London; cl: *Le Chahut (Study)*, Seurat, Courtauld Institute, London; bc: *Le Chahut*, Seurat, State Museum Kröller-Müller, Otterlo, Netherlands.

pp. 16–17 *Invitation to the Sideshow (The Parade)*, Seurat, The Metropolitan Museum of Art, New York.

p. 17 tl: *Cirque*, Seurat, Musée d'Orsay, Paris.

p. 18 tr: *Self-Portrait*, van Gogh, AIC; c: *Still Life with Horse's Head*, Gauguin, Bridgestone Museum of Art, Tokyo; bl: *The Terrace of the Moulin, le Blute Fin, Montmartre*, van Gogh, Art Institute of Chicago; br: *Pair of Boots*, van Gogh, The Baltimore Museum of Art.

p. 19 tl: *The Restaurant de La Sirène, Asnières*, van Gogh, Musée d'Orsay; tr: *Interior of a Restaurant*, van Gogh, State Museum Kröller-Müller, Otterlo, Netherlands; cl: *The Italian Woman*, van Gogh, Musée d'Orsay, Paris; c: *Portrait of Père Tanguy*, Bernard, Kunstmuseum, Basel.

p. 20 l: *Avenue de Clichy*, Anquetin, Wadsworth Atheneum, Hartford, Conneticut; b: *Rue Lafayette*, Munch, Nasjonalgalleriet, Oslo.

pp. 20–21 *Iron Bridges at Asnières*, Bernard, The Museum of Modern Art, New York.

p. 21 tc: *Paris, Boulevard Montmartre at Night*, Pissarro, National Gallery, London.

p. 22 tr: *Tropical Vegetation, Martinique*, National Gallery of Scotland, Edinburgh; bl: *Landscape, Saint-Briac*, Bernard, Glasgow Museums and Art Galleries; br: *Four Breton Women*, Gauguin, Neue Pinakothek, Munich.

p. 23 tl: *The Vision after the Sermon*, Gauguin, National Gallery of Scotland, Edinburgh; br: *Landscape in the Bois d'Amour (The Talisman)*, Sérusier, Musée d'Orsay, Paris.

p. 24 c: *Sunflowers*, van Gogh, National Gallery, London; b: *Landscape with a Hawking Party*, Koninck, National Gallery, London.

pp. 24–25 *Peach Blossom in Le Crau*, Van Gogh, Courtauld Institute, London.

p. 26 tr: *Self-Portrait with Bandaged Ear*, van Gogh, Courtauld Institute, London; c: *Houses with Thatched Roofs*, van Gogh, Musée d'Orsay, Paris; bl: *Madame Gachet in the Garden*, van Gogh, Musée d'Orsay, Paris; br: *Portrait of Doctor Gachet*, van Gogh, Musée d'Orsay, Paris.

p. 27 cr: *Cypress Against a Starry Sky*, van Gogh, State Museum Kröller-Müller, Otterlo, Netherlands.

p. 28 tr: *Portrait of Huysmans*, Forain, Musée de Versailles, Paris; cl: *Pays Doux*, Puvis de Chavannes, Yale University Art Gallery; br: *The Sirens*, Moreau, Musée Gustave Moreau, Paris.

p. 29 cr: *The Loss of Virginity*, Gauguin, The Chrysler Museum, Norfolk, VA; bc: *Evocation*, Redon, AIC; br: *Imaginary Portrait of Paul Gauguin*, Redon, Cabinet des Dessins, Louvre, Paris.

p. 30 tr: *Merahi Metua No Tehemana*, Gauguin, AIC;

p. 31 tl: *Mahana No Atua*, Gauguin, AIC; br: *Te Rerioa*, Gauguin, Courtauld Institute, London.

p. 32 cl: *Ambrose Vollard with his Cat*, Bonnard, Musée du Petit Palais, Paris.

pp. 32–33 *Catholic Mystery*, Denis, La Musée Départementale de la Prieuré, St. Germain-en-Loge.

p. 33 tl: *Madame Valloton and her Niece*, Vallotton, AIC; tr: *Mother and Daughter of the Artist*, Vuillard, New York Museum of Modern Art.

p. 34 tr: *Portrait of Emile Bernard*, Toulouse-Lautrec, Tate Gallery, London.

p. 35 tr: *Portrait of May Milton*, Toulouse-Lautrec, AIC.

p. 36 *At the Moulin Rouge*, Toulouse-Lautrec, AIC.

p. 40 tr: *The Little White Girl: Symphony in White, No.2*, Whistler, Tate Gallery, London; cl: *Coast of Brittany*, Whistler, Wadsworth Atheneum, Hartford Conneticut; bl: *Portrait of the Painter's Mother*, Whistler, Musée d'Orsay, Paris; br: *Arrangement in Grey: Portrait of the Painter*, Whistler, Detroit Institute of Arts.

p. 41 t: *Nocturne in Blue and Silver: Cremorne Lights*, Whistler, Tate Gallery, London; c: *Nocturne in Black and Gold: The Falling Rocket*, Whistler, Detroit Institute of Arts.

p. 42 bc: *Torso of a Woman in the Sunlight (Study)*, Renoir, Musée d'Orsay, Paris.

pp. 42–43 *Bathers*, Renoir, Philadelphia Museum of Art.

p. 43 bl: *Bathers, Plage de Pouldu*, Denis, Musée de Petit Palais, Paris; *The Bathers (Study)*, Renoir, AIC.

p. 44 tr: *Girls Running, Walberswick Pier*, Steer, Tate Gallery, London; cl: *The Apple Seller*, Renoir, The Cleveland Museum of Art; c: *Fish Sale on a Cornish Beach*, Forbes, Plymouth Art Gallery; bl: *A View of Quimperle*, Leech, National Gallery of Ireland.

pp. 44–45 *View from My Window, Eragny*, Pissarro, Ashmolean Museum, Oxford.

p. 46 tr: *Self-Portrait*, Cézanne, Musée d'Orsay, Paris; c: *Still Life with Milk Jug and Fruit*, Cézanne, National Gallery, London.

p. 47 tl: *Montagne Sainte-Victoire*, Cézanne, Courtauld Institute, London; tr: *Homage to Cézanne*, Denis, Musée d'Orsay, Paris.

p. 48 c: *Myself: Landscape Portrait*, Rousseau, National Gallery, Prague; cl: *Portrait of a Woman*, Rousseau, Musée d'Orsay, Paris; b: *The Snake Charmer*, Rousseau, Musée d'Orsay, Paris.

p. 48–49 *The Sleeping Gypsy*, Rousseau, The Museum of Modern Art, New York.

p. 49 br: *Tropical Forest with Monkeys*, Rousseau, National Gallery of Art Washington.

p. 50 tr: *Woman Pulling on her Stockings*, Toulouse-Lautrec, Musée d'Orsay, Paris; cl: *The Voice*, Munch, Munch Museum, Oslo; br: *The Punishment of Luxury*, Segantini, Walker Art Gallery, Liverpool.

p. 51 tl: *Masks and Death*, Ensor, Musée d'Art Moderne, Liege; tr: *Judith I*, Klimt, National Art Gallery, Prague; cl: *Die Pest*, Böcklin, Kunstmuseum, Basel; bl: *The Camden Town Murder (or What Shall We Do for the Rent?)*, Sickert, Yale Center for British Art.

p. 52 cl: *The Scream*, Munch, Munch Museum, Oslo; *Evening on Karl Johan Street*, Munch, Munch Musuem, Oslo.

pp. 52–53 *The Dance of Life*, Munch, Nasjonalgallaeriet, Oslo.

p. 53 bl: *Puberty*, Munch, Munch Museum, Oslo; br: *Death in the Sickroom*, Munch, Munch Museum, Oslo.

p. 56 *The Rehearsal*, Degas, Glasgow Museums and Art Galleries.

p. 58 c: *Setting Sun (part of Waterlilies series)*, Monet, Musée de l'Orangerie, Paris.

p. 59 c: *Waterlily Pond*, Monet, Bridgestone Museum of Art, Tokyo; tr: *Irises at the Side of the Pool*, Monet, AIC; bl: *Path with Rose Trellises at Giverney*, Monet, Musée Marmottan, Paris.

p. 60 tr: *Fruit Bowl with Pears and Apples*, Picasso, National Gallery, London; br: *Paysage*, Braque, Kunstmuseum, Basel.

p. 61 c: *Bathers*, Cézanne, Musée de Petit Palais, Paris; tr: *Luxury, Calm and Delight*, Matisse, Musée d'Orsay, Paris; bl: *Nude in the Studio*, Matisse, Bridgestone Museum of Art, Tokyo.

Glossary

Abstract art Art that expresses or suggests ideas that are independent of the direct representation of external reality.

Avant-garde Any group of artists thought to be the most innovative and progressive of their time in subject matter or technique.

Classicism The antithesis of Romanticism; characterized by clarity and excellence of "classic" form and technique.

Cloisonné Brightly colored decorative enamelling divided into separate cells or "*cloisons.*"

Complementary colors Two colors are "complementary" if they combine to complete the spectrum. So the complementary of each primary color – red, blue, and yellow – is the combination of the other two. Red and green; blue and orange; and yellow and violet are the basic pairs. In painting, placing complementary colors next to each other makes both appear brighter.

Flat color An unmodeled area of color – an evenly applied, unvaried expanse of red, for example.

Impressionism First used derisively, the term derived from the title of a painting exhibited by Monet in 1874. Monet, Pissarro, Renoir, and others exhibited together independently of the official Salon in Paris. Painting *en plein air* (outdoors), they mastered a broken or flickering brushwork that effectively captured the fleeting quality of light.

"Complementary" colors

Medium In paint, the vehicle (substance) that binds the pigment – for instance, in oil paint the medium is an oil (linseed oil, etc).

Naturalism Art that represents objects as they are observed.

Old Master A quality painting or artist, specifically from 13th- to 17th-century Europe.

Palette Both the flat surface on which an artist sets out and mixes paints, and the range of pigments used in painting.

Pastel A stick of powdered pigment mixed with just enough gum to bind the particles. (Also the name for a work of art using pastel.)

Realism The French art movement, led by Gustave Courbet, that rejected the academic tradition in favor of unidealized paintings of ordinary people and objects.

Romantic The term used to describe work by artists like Delacroix and Turner. Characteristics include overt emotion, drama, and an affinity with the natural world.

Still life A painting of inanimate objects such as flowers or fruit.

Synthesize The depiction of ideas or emotions as opposed to naturalistic representations of form.

Theosophy Any philosophy professing to achieve a knowledge of God by spiritual ecstasy.

Woodcut Relief print made from cutting into a design drawn on wood with a knife, gouge or chisel. The raised surface is inked and printed on paper.

Index

Acknowledgments

PICTURE CREDITS

Every effort has been made to trace the copyright holders and we apologize in advance for any unintentional omissions. We would be pleased to insert the appropriate acknowledgment in any subsequent edition of this publication.

Key:
t: top *b*: bottom *c*: center *l*: left *r*: right

Abbreviations:
AIC: © The Art Institute of Chicago, All Rights Reserved; **BAL**: Bridgeman Art Library; **BIF**: Bibliothèque de l'Institut de France, Paris; **BM**: Trustees of the British Museum, London; **BN**: Bibliothèque Nationale, Paris; **CG**: Courtauld Institute Galleries, London; **KM**: Collection State Museum Kröller-Müller, Otterlo, Netherlands; **MET**: Metropolitan Museum of Art, New York; **ML**: Musée du Louvre, Paris; **MO**: Musée d'Orsay, Paris; **MOMA**: Museum of Modern Art, NewYork; **NGL**: Reproduced by courtesy of the Trustees, The National Gallery, London; **NGL/ BC**: Berggruen Collection, on loan to the National Gallery, London; **NGO**: Nasjonalgalleriet, Oslo; **NGW**: © National Gallery of Art, Washington; **NPG**: By courtesy of the National Portrait Gallery, London; **OKKB**: Oeffentliche Kunstsammlung, Kunstmuseum, Basel; **PC**: Private Collection; **PVP**: Photothèque des Musées de la Ville de Paris; **RMN**: Réunion des Musées Nationaux, Paris; **TG**: Tate Gallery, London: **V&A**: Courtesy of the Board of Trustees of the Victoria and Albert Museum

Front cover: Clockwise from top left: MO; BIF; MO; MO; Musée Français de la Photographie, Bièvres; MO/ RMN; *Jane Avril Dancing,* Toulouse-Lautrec, MO; *Roses and Anemones,* Vincent van Gogh, MO; *c: Café Terrace at Night,* Vincent van Gogh, KM **Back cover:** Clockwise from top left: MO; BN; MO; *Mont Saint-Victoire and Château Noir,* Paul Cézanne, Bridgeman Museum of Art, Ishibashi Foundation, Tokyo; *Achille Emperaire,* Paul Cézanne, MO; *At the Moulin Rouge* (detail), ASIC (also *c, cl*); MO; MO; "Nuits à Paris," illustrated by A. Willette, 1889, BIF; MO **Inside front flap:** *t*: © Munch Museum, Munch Estate, Bono, Oslo/ DACS, London 1993 **p1:** MO **p2:** *tl*: NGL; *tr*: BN; *cl*: MO; *c, cr*: NGL/ BC; *bl*: MO/ RMN; *br*: MO **p3:** *t*: © Munch Museum, Munch Estate, Bono, Oslo/ DACS, London 1993; *b*: NGO/ photo J. Lathion © Munch Museum, Munch Estate, Bono, Oslo/ DACS, London 1993; *tr*: Galerie Janette Ostier, Paris/ Giraudon; *c*: V&A; *bl*: *Le Carnet de Paul Gauguin,* (Paris 1952), ed. René Huyghe. facsimile edition, with thanks to Quatre Chemins éditarts, Paris and the Musée Gauguin, Tahiti; *br*: Musée Gauguin, Tahiti; *b*: MO **p24:** *cl*: Robert Allerton Fund, photograph by Kathleen Culbert-Aguilar, Chicago © 1993 AIC **pp24–25** *c*: BM; *b*: Margaret Day Blake Collection, © 1989 AIC **p26:** *tr*: CG; *c, bl, br*: MO; *br*: KM; *br*: MO **p28:** *tr*: BN; *tr*: Musée de Versailles, Paris/ RMN © DACS 1993; *cl*: Yale Univesity Art Gallery, The Mary Gertrude Abbey Fund; *bl*: Lee M. Friedman Fund, Courtesy of Museum of Fine Arts, Boston; *br*: Musée Gustave Moreau/ RMN **p29:** *tl*: Musée de Petit Palais, Paris/ PVP © DACS 1993; *tc*: BC/ NGL; *c*: BN; *cr*: The Chrysler Museum, Norfolk VA. Gift of Walter P. Chrysler Junior; *br*: Joseph Winterbotham Collection, © 1993 AIC; *br*: Cabinet des Dessins, ML/ RMN **p30:** *tl*: MO; *tr*: Gift of Mr. and Mrs. Charles Deering McCormick. © 1988 AIC; *c*: Gift of Tiffany and Margaret Blake, © 1992 AIC; *bl*: Noa Noa facsimile edition (1987) with thanks to Editions Avant et Après; *b*: Clarence Buckingham Collection. © 1988 AIC **p31:** *tl*: Helen Birch Bartlett Memorial Collection, © 1992 AIC; *tr*: Ancient Art and Architecture Collection; *cl, bl* (detail): MO; *cr*: Werner Forman Archive; *br*: CG **p32:** *cl*: Musée de Petit Palais, Paris/ PVP/ © ADAGP/ SPADEM, Paris and DACS, London 1993; *bl*: Collection Arthur Galtshul/ Giraudon **pp32–33:** *c*: La Musée Départementale de la Prieure/ Studio Lourmel, photo Rolithier/ © DACS 1993 **p33:** *tl*: Bequest of Mrs. Clive Runnells © 1993 AIC; *tr*: MET/ Joseph S. Martin, Artothek/ DACS 1993 **p34:** *tr*: TG; *bc*: MO; *br*: Musée Toulouse-Lautrec, Albi/ Flammarion- Giraudon; *bl*: Musée /Toulouse-Lautrec, Albi **p35:** *t*: PVP/ © DACS 1993; *tc*: Musée Toulouse-Lautrec, Albi; *tr*: Bequest of Kate L. Brewster © 1993 AIC; *bc*: Mr. and Mrs. Carter H. Harrison Collection © 1993 AIC; *br*: Musée Carnavalet/ PVP/ © ADAGP, Paris and DACS, London 1993 **p36:** *t*: Helen Birch Bartlett Memorial Collection © 1992 AIC **p38:** *tl*: MO/ RMN; *tc, tr*: MO/ © ADAGP/ SPADEM, Paris and DACS, London 1993; *cl*: ML/ BAL; *b*: MO/ RMN **p39:** *tl, tcl, bl*: Musée d'Orsay, Paris, RMN, MO/ © ADAGP/ SPADEM, Paris and DACS, London 1993; *tc, tr, cr*: MO/ RMN **p40:** *tr*: TG; *bc*: Musée d'Orsay, Paris **p41:** *t*: © Wadsworth Atheneum, Hartford, Connecticut, USA. In Memory of William Arnold Healy, Given by his daughter, Susie Healy Camp; *bl*: MO; *br*: The Detroit Institute of Arts. Bequest of Henry Glover Stevens in memory of Ellen P. Stevens and Mary M. Stevens **p41:** *tl*: TG; *bl*: the Detroit Institute of Arts. Gift of Dexter M. Ferry Jr.; *bc*: Courtesy of the Fogg Art Museum, Harvard University Art Museums, Bequest of Grenville L. Winthrop; *br*: NPG; *br*: V&A **p42:** *cl*: Villa Farnesina, Rome/ Scala; *c*: BN; *br*: MO **pp42–43:** *c*: Philadelphia Museum of Art: Mr. and Mrs. Caroll S. Tyson Collection **p43:** *tl*: Musée de Petit Palais/ PVP/ © DACS 1993; *br*: Bequest of Kate L. Brewster, © 1990 AIC **p44:** *tr*: TG; *b*: The Cleveland Museum of Art, Bequest of Leonard C. Hanna Jnr; *c*: Plymouth Art Gallery; *bl*: Courtesy of the National Gallery of Ireland **pp44–45:** *c*: Ashmolean Museum, Oxford **p45:** *tl*: Gift of Marjorie Blum Kolver Collection, Harry and Marible G. Blum Foundation, ©1992 AIC; *c*: Ashmolean Museum, Oxford **p46:** *tr*: MO; *c*: NGL/ BC; *bl*: BN; *br*: © Robert Doisneau/ RAPHO **p47:** *tl*: CG; *tr*: MO/ RMN/ © DACS 1993; *cl*: ML/ RMN; *c, cr*:NGL/ BC; *br*: NGL **p48:** *c*: National Gallery, Prague; *cl, b*: MO/ RMN **pp48-49:** *c*: MOMA. Gift of Mrs. Simon Guggenheim **p49:** *bl*: © CollectionViollet; *tr*: NGW/ Visual Arts Library **p50:** *tr*: MO; *cl*: © Munch Museum, Munch Estate, Bono, Oslo/ DACS, London 1993; *c*: BN; *br*: Board of the Trustees of the National Museums and Galleries of Merseyside (Walker Art Gallery, Liverpool) **p51:** *tl*: Musée d'Art Moderne,Liege/ Artothek/ © DACS 1993; *cl*: OKKB, Deposutum Eidg. Gottfried-Keller-Stiftung; *tr*: National Gallery, Prague/ Artothek; *bl*: Yale Center for British Art, Paul Mellon Fund **p52:** *tc*: © Munch Museum, Munch Estate, Bono, Oslo/ DACS, London 1992; *cl*: © Munch Museum,

Additional Photography
Philippe Sebert: **Front cover:** *tl*; *br*; *tcr*; *tcl*; *bcl*; **Back cover:** *tr*; *tc*; *cr*; *br*; *bcr*; *cl*; *pl*; **p2:** *cl*; **p3:** *tl, bl, br*; **p4:** *bl*; **p10:** *cl, br*; **pp10-11:** *t* **p12:** *bc*; **p15:** *bl*; **p17:** *tl*; **p19:** *tl, cl*; **p23:** *br*; **p26:** *bl, c, br*; **p27:** *br*; **p30:** *bl*; **p38:** *tcl, tr*; **p39:** *tl, tc, bl*; **p40:** *bc*; **p42:** *c*; **p46:** *tr*; **p48:** *cl, b*; **p50:** *c*; **p55:** *bc*; **p56:** *tl*; **p57:** *bc*; **p61:** *tl, tr* Alison Harris: **Front cover:** *tr, br, bl*; **p2:** *tl, cr*; **p56:** *bc*; **p62:** Philip Gatward: **p23:** *bc*; **p30:** *bl* Susanna Price: **p31:** *cl, bl*; **p58:** *tl*; **p59:** *tl* Alex Sanderson: **p58:** *c, br*; **p59:** *bl, br*

Dorling Kindersley would like to thank:
Robert Sharp and the staff at the Art Institute of Chicago; Peter Jones for editorial assistance; Job Rabkin and Jo Walton for additional picture research; Hilary Bird for the index.

Author's acknowledgments:
Richard Kendall provided much of the original inspiration for this book so special thanks are due to him. Thanks also to Phil Hunt, Mark Johnson Davies, and Gwen Edmonds at Dorling Kindersley for their reassuring and unflappable professionalism. And finally, thanks to my wife Pat, for fearlessly helping me to tame the word-processor.

1993; *tr*: Mr. and Mrs. Lewis Larned Coburn Memorial Collection © 1993 AIC; *cl*: © 1993 NGW, Chester Dale Collection; *c*: Gift of Mrs. Leigh Block, © 1991 AIC; *b*: OKKB **p8:** *cl*: Glasgow Museums: The Burrell Collection; *b*: Aberdeen Art Gallery **pp8–9:** *c*: Helen Bartlett Memorial Collection, © 1992 AIC **p9:** *cr*: © 1993 NGW, Chester Dale Collection; *bl*: Gift of Margaret Day Blake Collection, Mr. and Mrs. Henry C. Woods, and William McCallin McKee Memorial Funds, © 1989 AIC; *br*: The National Museum of Western Art, Tokyo, Matsukada Collection **p10:** *tl*: © 1993 NGW, Collection of Mr. and Mrs. Paul Mellon; *cl, br*: MO; *bl*: Roger-Viollet, Paris **pp10–11:** *t*: MO **p.11:** *tr*: MO/ RMN **p12:** *br*: MET, Robert Lehman Collection, 1975; *c*: ML/ RMN; *bc*: MO **pp12-13:** *c*: NGL/ BC **p13** *bl*: Bardo Museum, Tunis/ Sonia Halliday Photographs; *br*: ML/ BAL **p14:** *t, c*: BIF; *tr*: BN **bl**: BN; *br*: Glasgow Museums: Art Gallery and Museum, Kelvingrove, © DACS 1993 **p15:** *tl, tr* (detail): Glasgow Museums: Art Gallery and Museum, Kelvingrove, © DACS 1993 *c*: ÖKKB; Dr. Emile Dreyfus Stiftung; *bl*: MO; *br*: BN **p16:** *cl, tr*: MO; *bl*: BN **p16-17:** MET, Bequest of Stephen C. Clark, 1960 (61. 101. 17) **p17:** *tl*: MO; *tr*: Sonia Halliday Photographs **p18:** *tr*: The Joseph Winterbotham Collection © 1990, AIC; *cl*: Bridgestone Museum of Art, Ishibashi Foundation, Tokyo; *bl*: Helen Birch Bartlett Memorial Collection, © 1989 AIC; *br*: The National Museum of Art; The Cone Collection, formed by Dr. Claribel Cone and Miss Etta Cone of Baltimore, Maryland, BMA 1950.302 **p19:** *tl*: MO; *tr*: KM; *cl*: MO; *c*: OKKB © DACS 1993; *bl*: Musée Gustave Moreau, RMN/Paris; *br*: PC, Paris/ BAL **p20:** *tl*: The Hulton Deutsch Collection; *tr*: NGL/BC; *cl*: Wadsworth Atheneum Hartford Conneticut, USA, The Ella Gallup Sumner and Mary Catlin Sumner Collection. Endowed in memory of Louis M. Beckenstein by the Beckenstein Family/ © DACS 1993; *b*: NGO/ photo J. Lathion © Munch Museum, Munch Estate, Bono,Oslo/ DACS, London 1993 **pp20-21:** MOMA, Grace Rainey Rogers Fund © DACS 1993 **p21:** *tl*: NGL **p22:** *tl*: BN; *tr*: National Gallery of Scotland, Edinburgh; *cl*: Cabinet des Dessins, ML/ RMN; *bl*: Glasgow Museums: Art Gallery and Museum, Kelvingrove, © DACS 1993; *br*: Neue Pinakothek, Munich/ Artothek **p23:** *tl*: National Gallery of Scotland, Edinburgh; *tr*: Galerie Janette Ostier, Paris/ Giraudon; *c*: V&A; *bl*:

Rasmus Meyers' Collections, Bergen, Munch Museum, Munch Estate, Bono, Oslo/ DACS, London 1993 **pp52-53:** *t*: photo: J.Lathion/ NGO © Munch Museum, Munch Estate, Bono, Oslo/ DACS, London 1993 **p53:** *bl, br*: © Munch Museum, Munch Estate, Bono, Oslo/ DACS, London, 1993 **p54:** *t*: Musée Rodin, Paris/ © ADAGP, Paris and DACS, London 1993; *r*: Musée Rodin, Paris/ photo: Bruno Jarret/ © ADAGP, Paris and DACS, London 1993; *c*: Statens Museum for Kunst, Copenhagen/ photo: Hans Petersen; *bl*: © Glasgow Museums: The Burrell Collection **p55:** *tl*: Gift of Walter S. Brewster © 1993 AIC; *tr*: MO/ RMN; *bl*: Musée Rodin, Paris/ ADAGP, Paris and DACS, London 1993; *bc*: MO/ © DACS 1993 **p56:** *tl*: MO; *tr, bl, br*: BN; *c*: Glasgow Museums: The Burrell Collection; *bc*: Musée Français de la Photographie, Bièvres (Fondé et animé depuis 1960 par Jean et André Fage) **p57:** *tl*: Musée Gustave Moreau, Paris/ RMN; *tr*: Bequest of Mrs. Stirling Morton, © 1990 AIC; *cl*: Gift of Nathan Cummings, © 1993 AIC; *cr*: Mr and Mrs Martin A. Ryerson Collection, © 1992 AIC; *bl*: RMN; *br*: MO **p58:** *tr*: Monet's House and Garden at Giverney; *tr*: BN; *c*: Musée de l'Orangerie, Paris **p59:** *tl, bl, :* Musée Marmottan, Paris; *tr*: Art Institute Purchase Fund, © 1988 AIC; *c*: Bridgestone Museum of Art, Ishibashi Foundation, Tokyo **p60:** *tr*: NGL/ BC/ © DACS 1993; *c*: BN; *cl*: OKKB/ photo: Martin Bühler/ © DACS 1993; *b*: © Robert Doisneau, RAPHO; *br*: OKKB, Schenkung Raoul la Roche, Photo: Martin Bühler/ © ADAGP, Paris and DACS, London 1993 **p61:** *tl*: Musée du Petit Palais, Paris; *tr*: MO/ © Succession H. Matisse/ DACS 1993; *bl*: Bridgestone Museum of Art, Ishibashi Foundation, Tokyo/ © Succession H. Matisse/ DACS 1993; *cr*: BM Dept. of Prints and Drawings **p62:** *t*: Through prior bequest of the Mr. and Mrs. Martin A. Ryerson Collection © 1993 AIC; *b*: BIF